MALE TO FEMALE

"La Cage aux Folles"
MALE TO FEMALE

PHOTOGRAPHS BY VIVIENNE MARICEVIC

TEXT BY VICKI GOLDBERG

EDITION STEMMLE

CONTENTS

CLOTHES MAKE THE MAN

VICKI GOLDBERG

So there's this guy presenting himself, as guys will, to be photographed – wearing a knit muffler, or a bathrobe, or a T-shirt that bares his tattoos. He's not particularly handsome or ugly or for the most part exceptional or odd; he tends to put on confidence for the camera, as sitters do, or maybe, in this day and age, he lets the wariness slip through. And then in the next two pictures, in a blitz of garter belts and curlers and tulle, he is radically transformed into – a feminine version of himself. In Vivienne Maricevic's New York photographs the masquerade isn't often very convincing (which could have something to do with the men who wanted to pose), but hey, a lot of us are masquerading as some self we'd like to be, and we're not always so convincing either.

Anyway, drag queens aren't necessarily interested in mere verisimilitude. Note the man with the marabou, the dangling rhinestones, the amazing

sequined eyelids and the luxurious gray moustache. Or the rather ordinary fellow in the watchcap who remakes himself first as a fairly credible parody of some diva like Maria Callas and then as virtually a set design of a tired 1950s slut, in prom dress, long gloves, a poor man's ransom of fake pearls, determinedly useless sunglasses and sufficient hair to refurbish a flock of shorn sheep.

The transvestites aren't necessarily any more believable than the drag queens. A lot of them, their patently male faces set off by wigs, their broad shoulders protruding from sleeveless dresses, look exactly like what they are: men in drag. Their aims were never quite the same as the drag queens'. They never meant to push the idea of femininity past the point of no return.

A word on definitions: in psychoanalytic terms, drag queens (and female impersonators) are male homosexual cross-dressers in conscious control of the amount and times of their cross-dressing. Some are quite convincing as females, and some even operate now and then as female prostitutes. Their personalities and costumes tend to the theatrical. Transvestites are heterosexual by preference and identify themselves primarily as male, though they have a female identity too and a female name to go with their garter belts and dresses. Many are married and have children; their wives may or may not know about their cross-dressing. This runs the gamut from wearing women's panties under a man's suit every day to dress-up after work to spending life in skirts, but transvestism is a kind of addiction or obsession, and though generally periodic, under stress becomes compulsive.[1]

Then there are transsexuals: males so desperate not just to look like but somehow to *be* female that they have undergone sex change operations. The men with breasts in Maricevic's single images might

1 See John Money, *Venuses Penuses: Sexology Sexosophy and Exigency Theory*, Buffalo, NY: Prometheus Books, 1986, p. 380; and Ethel Spector Person and Lionel Ovesey, "Homosexual Cross Dressers" in: *Journal of the American Academy of Psychoanalysis*, vol. 12, no. 2, 1984, pp.180/181.

be pre-op(eration) transsexuals. (They are not herm-aphrodites, a term properly reserved for individ-uals born with both male and female organs, nei-ther of which is likely to be fully developed.[2]) Reputable medical centers that perform sex change operations require the patient to take hormones and live for a minimum of a year dressed and work-ing as a woman before undergoing the final, irre-versible genital surgery.

They might well be transvestites on hormones, who sometimes refer to themselves as "breast fetish-ists"[3]. Whatever they are, they resemble a gender on the road to fulfillment: hormones diminish body hair, raise voices, shrink sexual organs and eventually make erection impossible, at which point many of them stop. Some make a living turning tricks as *double entendres*. They advertise in the back of "Screw" magazine ("Chicks with Dicks", "The Third Sex"); Maricevic says she took some of their publicity pictures.

A few transvestites do ultimately elect surgery, but far the greater majority identify themselves as males who get a charge out of wearing women's cloth-ing; their male member is an essential part of their identification. Robert J. Stoller, who laid the groundwork for contemporary gender studies, wrote, "The transvestite fights this battle against being destroyed by his feminine desires, first by alternat-ing his masculinity with the feminine behavior, and thus reassuring himself that it isn't permanent; and second, by being always aware even at the height of feminine behavior – when he is fully dressed in women's clothes – that he has the absolute insignia of maleness, a penis." (Transsexuals, on the other hand, loathe all the male physical characteristics.[4])

At any rate, they have become some hybrid sex that nature never devised and most of us have never seen, a kind of dual gender unrecognized by printed forms that ask you to check "M" or "F". These guys

2 My thanks to Dr. Gideon Horowitz for information on this and other matters relating to transvestites and transsexuals.
3 Lionel Ovesey and Ethel Person, "Transvestism: A Disorder of the Sense of Self" in: *International Journal of Psychoanalytic Psychotherapy*, vol. 5, 1976, p. 226.

4 Robert J. Stoller, *Sex and Gender: On the Development of Masculinity and Femininity*, London: The Hogarth Press and the Institute of Psychoanalysis, 1968, vol. 1, p. 186; Transsexuals: Lionel Ovesey and Ethel Person, "Gender Identity and Sexual Psychopathology in Men: A Psychodynamic Analysis of Homosexuality, Transsexualism, and Transvestism" in: *American Academy Psychoanalysis*, 1 (1), New York, NY: John Wiley and Sons, 1993, p. 65.

have recreated themselves as the phallic mother of fantasy, the woman who has not been castrated after all. They insist on their place between the sexes by wearing women's underwear that reveals what women never can; after a while this collection of images begins to seem like a lingerie catalogue on testosterone.

The visible facts may be off-putting at first for those who are not familiar with the phenomenon. We react differently to men and to women and certainly differently to male bodies and female; here one must at least momentarily entertain opposite reactions, an uncomfortable mental trick. Roland Barthes spoke of "the terror of uncertain signs".

Transvestites, hybrids, transsexuals: all of them raise questions for straights: what do we mean by male and female? is biology destiny? if sex is one of the first things we notice, one of the first things we need to know about anyone we meet, how do we determine it? are gender roles entirely constructed, a product of upbringing, social pressure, visual cues, and fantasy?

True transsexualism as a public phenomenon goes back only to 1953, when Christine Jørgensen became a media sensation. Cross-dressing, however, is ancient. There are prohibitions against it in the bible, and among the church's complaints about St. Joan was that she adopted male attire. (Female-to-male cross-dressing is another story.) In Renaissance times, cross-dressing was closely associated with the theater, where boys played all the women's roles. In "As You Like It", "Twelfth Night", and "The Merchant of Venice", the women accomplish their ends by pretending to be men, producing a convoluted series of gender twists where a boy plays a girl disguised as a boy. The stage (and Mardi Gras or masquerade ball, both of which are theatrical in nature) is still almost the only place where

male-to-female cross-dressing is fully accepted in society.

Maricevic's triptychs of transformation connect to all the theatrical images in our minds. We know from photographs how actors can change their age, personality, sex and degree of monstrousness with make-up and costume. The men in this book are simply unprofessional, if almost painfully dedicated, actors – or perhaps more accurately, professional actors who are not on the professional stage. Recently Dustin Hoffman went through the minutiae of transformation in "Tootsie", Robin Williams in "Mrs. Doubtfire", Jeremy Irons and John Lone in "M. Butterfly". In "Tootsie", the traditional theatrical gender shift (boy playing girl) was subverted when Hoffman's character momentarily forgot he was playing Dorothy and moved to kiss Jessica Lange, which she interpreted to mean that Dorothy was a lesbian and should not marry her father.

The process of fabricating a new self is an idea with a strong hold on the current era. The promise of a transformed life and personality makes best-sellers of self-help and self-improvement books and underlies the appeal of the newer religions and therapies. And for several decades, the notion that gender and gender roles could be manufactured has riveted both scholarly and popular interest. Feminists argued against raising children along sex-stereotyped lines, sparking interest in androgyny. Gays came out of the closet and openly influenced style. Popular culture was mesmerized by divergent gender identifications.

From Ed Wood's awesomely bad "Glen or Glenda" to the sublime "Some Like it Hot", from "Psycho" to "Pink Flamingos" to the French "La Cage aux Folles" to "Dressed to Kill", "The Rocky Horror Picture Show", "Victor Victoria", "Yentl" and "The Crying Game", movies brought the public images of

cross-dressing. Liberace and Little Richard flaunted their feminine sides, Boy George made a career of long hair and women's clothing, Madonna went on tour in a pin striped suit with a bullet-brassiere poking through slits in the jacket, k. d. lang was doggedly indeterminate. In one two-year period in the early nineties, Donahue had at least 16 programs on cross-dressing and transsexualism and Geraldo had seven.[5]

Gender role became a salable item. A few years ago, Ken, Barbie's steadfast boyfriend, was marketed wearing a dress. Calvin Klein, who had already done so much to turn lightly clad men into sex objects in ads, put out a line of women's briefs that looked like men's without the fly.

All these instances seemed profoundly emblematic of a moment that was newly confused about its own identity. Both scholars and pop culture insisted that identity was fluid rather than fixed, construct-ed rather than inborn and inevitable. Cross-dressers began to seem almost emblematic of the duality and bewilderment that pervaded contemporary life, when boundaries were breaking down not only between gender roles but between high and low culture, public and private life, news and entertainment. Marjorie Garber, in her admirable book, "Vested Interests: Cross-Dressing and Cultural Anxiety", speaks of "the extraordinary power of the transvestite as an aesthetic and psychological agent of destabilization, desire, and fantasy".

The men in these photographs, elaborately constructing a contrary role for themselves, are reminders of how often the rest of us do something similar. Your ordinary man gets up in the morning worried about money, bursting with love, angry at his boss, anxious about his X-rays, then does the habitual thing, taking his work role out of the

5 On Phil Donahue and Geraldo Rivera, see Marjorie Garber, *Vested Interests: Cross-Dressing and Cultural Anxiety*, New York, NY: Harper Perennial, 1993, p. 5.

closet: dark-suited lawyer, brown-uniformed UPS man, blue-jeaned computer programmer.

Women have a bit more leeway, depending on their professions and the time of day. They can elect to look businesslike or fashionable, crisp or soft; they can try on for an evening the fantasy of being more beautiful and sexy than they suppose they really are. They can even profitably put on men's wear. Men find women in men's clothing sexually exciting – as Marlene Dietrich was in "Morocco" wearing tails and kissing a woman – whereas women are seldom turned on by a man in woman's clothes.

Male or female, core gender identity (I am a man, I am a woman) begins to be established before children are one year old and is fully developed by the age of three, but gender role identity (I am masculine, I am feminine) is worked out in numerous ways with reference to social cues and standards.

Role identity is inherently fluid; analysts say it is being constructed and reconstructed all the time.[6]

Women have always known how much the visual cues count, how much of the image is manufactured. The makeover used to be a popular feature in fashion magazines; hair dyes and anti-aging creams are watered-down versions. Girdles, waist-cinchers, merry widows (all of them coming back) repaired and improved; now there's spandex, fanny shapers, the wonder bra. At a somewhat more profound level there's diet – endless numbers of diets – and workouts. Then face scraping, collagen, silicone injections, monkey gland injections, hair implants, face lifts, nose jobs: technology has made possible the manufacture of new women, new men, and new gender for those who wish to ignore the X- and Y-chromosomes they were born with. (The female to male sex change operation has been much less successful than the male to female. There was one report of an

6 See Ovesey and Person, "Gender Identity", p. 54.

operated female whose penis fell off, causing him great distress. As one might imagine.)

Perhaps these aids, restoratives, regimens and reconstructions indicate how oppressed we are by the cult of youth and beauty, which admits only a few, and then for a limited term. But the wish to be someone else, or more than oneself, occurs to everyone from time to time. Transvestites and transsexuals make the common discontent visible on a distant, knife-like edge.

Even their unhappiness is extreme. In the 1990 film "Paris Is Burning", the African-American and Latino drag queens yearn for middle class glory: marriage, living outside New York, adopting children – or being a famous model, or just being famous and rich. Eternal outsiders without passports to the establishment, they compete at drag balls to look like what they cannot be, including executives. One competitive category is REAL, which means passing as something other that what you are. REAL could be a female prostitute or a bad dude but at all events it means convincing the straight world you are one of them. So whatever else you may be, you are certainly not quite real.

Different explanations have been given for the development of transvestites and transsexuals. Stoller hypothesizes that both are likely to be products of unhappy, depressed mothers in loveless marriages who keep their infant sons in such close contact with them that the child develops a female core identity. Lionel Ovesey and Ethel Person believe the issue is more likely to be negligent maternal care or illness and separation, leading to extreme separation anxiety and either a fantasy of symbolic fusion with the mother or a split male and female identification.[7] Some analysts are currently theorizing – it's only a theory so far – that something may go awry in the timing of normal hormonal

7 See Ovesey and Person, "Gender Identity", p. 64; Ovesey and Person,
"The Transsexual Syndrome in Males" in: *American Journal of Psychotherapy*, vol. 27, no. 1, January 1974, p. 185.

events *in utero*, producing a male child who inexplicably feels himself female in many ways.[8]

Transvestites and transsexuals are highly subject to depression and have a high rate of suicide. Today they have more than the usual goads to despair. Hormones are dangerous, the life of a man in female disguise can be violent, many are drug addicts, others contract AIDS. This book presents more than mere sexual bravado. A lot of the men who seductively, proudly, defiantly displayed their boas, their panties and their breasts to Maricevic have since died.

Maricevic, who has been photographing, publishing, and exhibiting since 1978, never had a photography course. In the late seventies, realizing that photographers were constantly presenting her with female nudes but seldom with naked males, she set out to change the equation. She advertised for subjects, got a lot of response, went to a lot of strangers' homes to photograph them. She says she's very attuned to people and quick to pick up signals, which must be true, as she also says she has never been in any danger. She went on to photograph male burlesque clubs, live sex shows, and the transvestite and transsexual communities at home in their SROs or wherever. Her equipment is simple: a 50 mm lens and either available light or a single photographic light.

Her photographs are documents from the fringe, giving us her subjects' home atmosphere and other secrets if not their public life. The format and subjects do not vary greatly; the presentation and technique are slightly raw, which is suitable enough for the content. Perfect prints are not of great interest to Maricevic; these people are. Sometimes she gives a few directions, suggesting this pose or that garment, or throwing them an item of women's underwear or stockings she has brought along.

8 Theoretical information provided by Gideon Horowitz.

(How they must love that, these men who fantasize about being initiated into transvestism by a woman, who seek a woman's advice on hair and makeup and accessories . . .)

Clearly they trust her, and no doubt she gives them reason. But of course they are exhibitionists, yearning to display the other selves they have created, "show girls" of a different stripe. Maricevic, perfectly at ease in their company, entirely non-judgmental, closely attentive and armed with a little machine to fix their image, must look like the answer to an exhibitionist's prayer.

Exhibitionism is a two-sided coin with voyeurism on the obverse. The two are inseparable; the exhibitionist scarcely exists without the voyeur. Photography, by nature voyeuristic, has extended the opportunities immeasurably. When the hand camera was first marketed in the late 1880s, the public was outraged to find itself constantly spied upon. As for Maricevic, she readily admits to being a voyeur and recalls that years ago her mother would take her to Times Square and point out the unusual people, or to traveling circuses, where the freak shows fascinated her. By now she has effectively made a profession of her fascinations.

And as for us – well, why are you looking at these pictures? Why am I? Who here is an exhibitionist, and who a voyeur? In the transaction between the photographs and the viewer, it just may be that more is being exposed than meets the eye.

Transvestites and Drag Queens

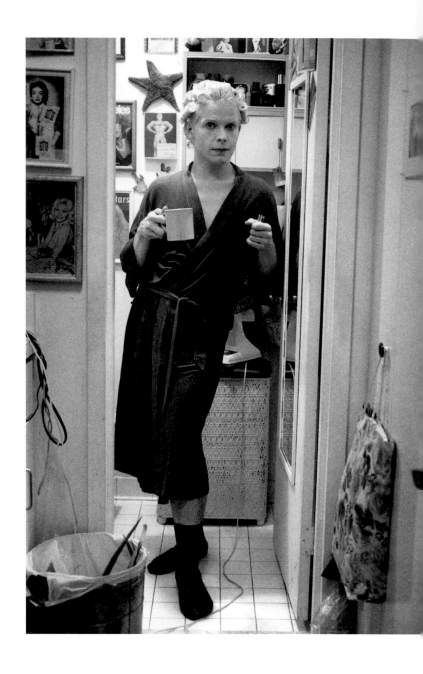

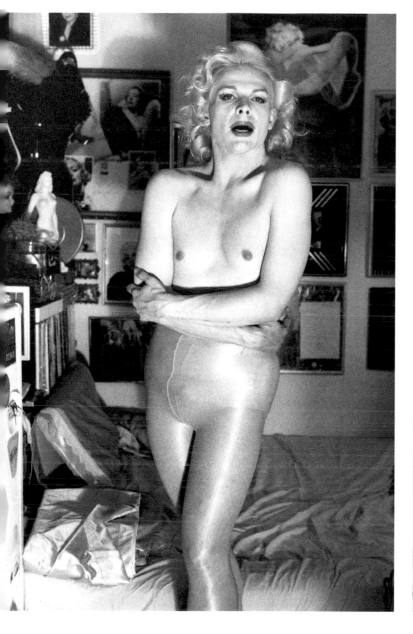 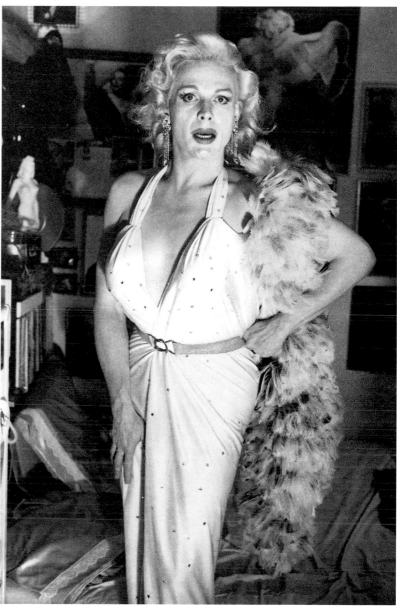

Guy/Miss Guy

Drag Queen

1989

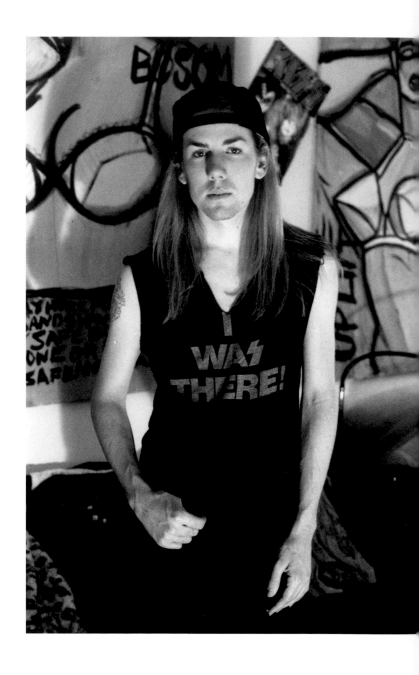

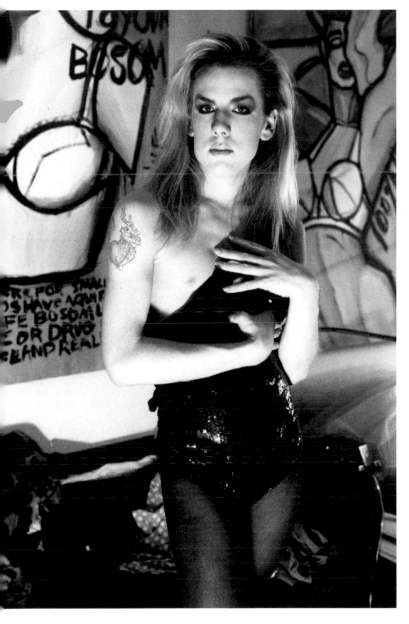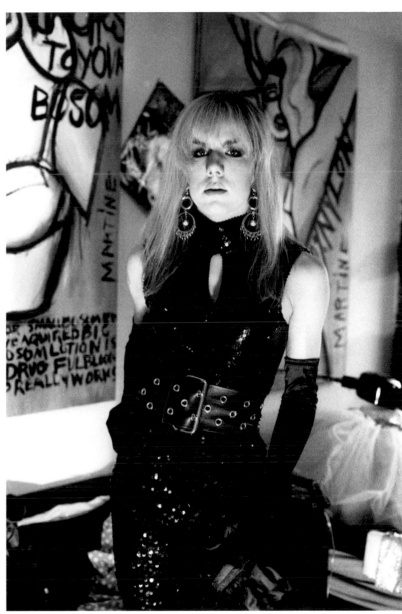

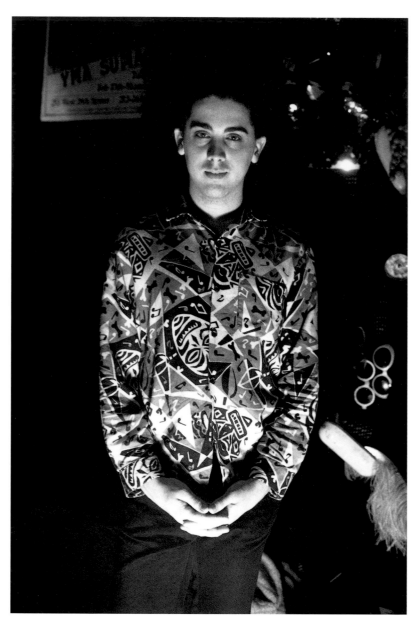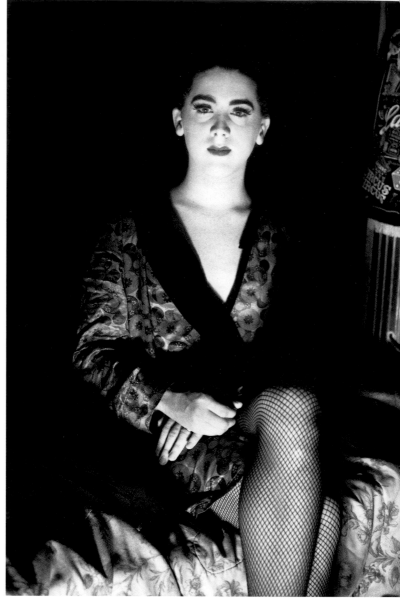

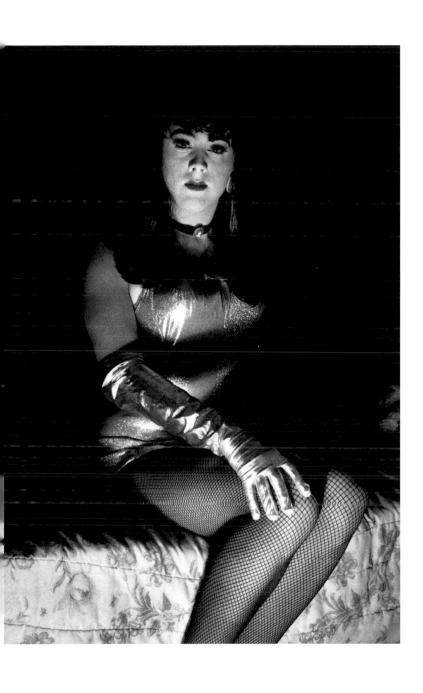

John/Laura

Transvestite

1988

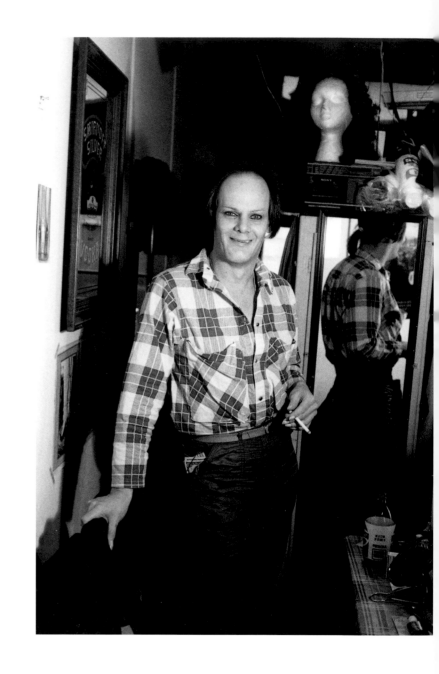

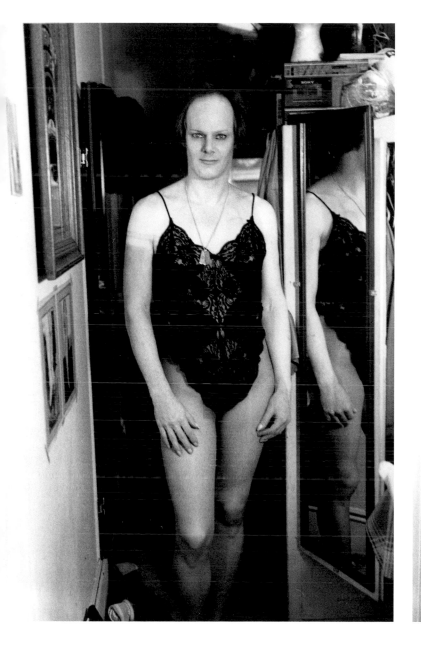
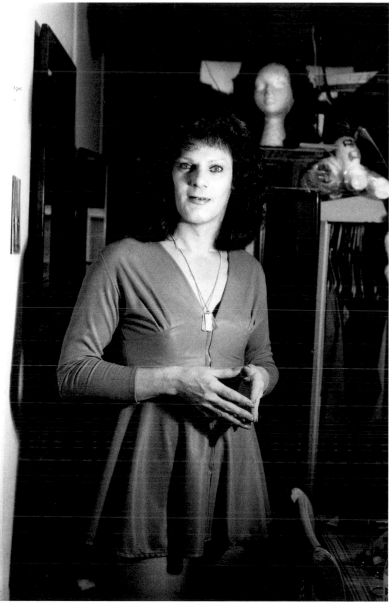

Joe/Diane

Transvestite

1989

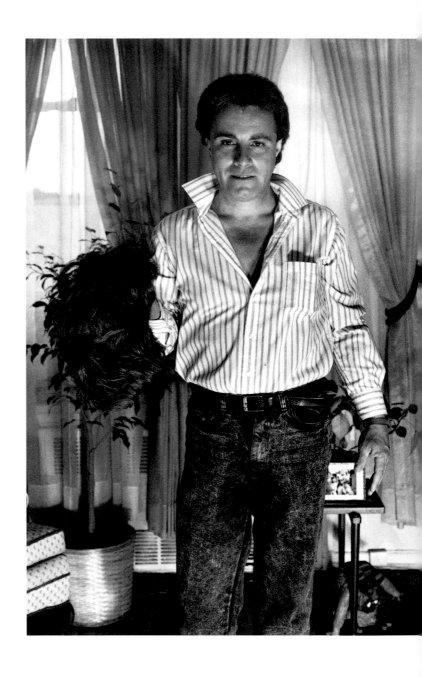

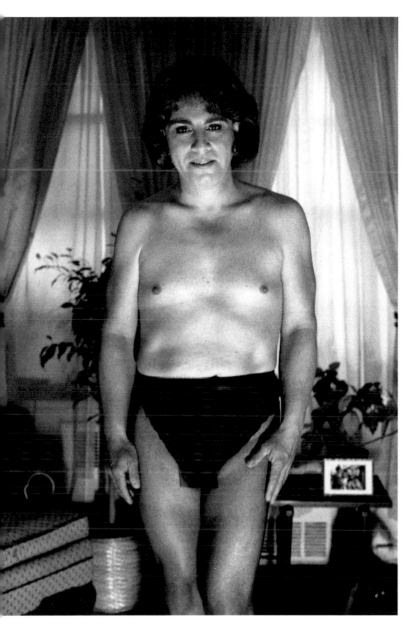 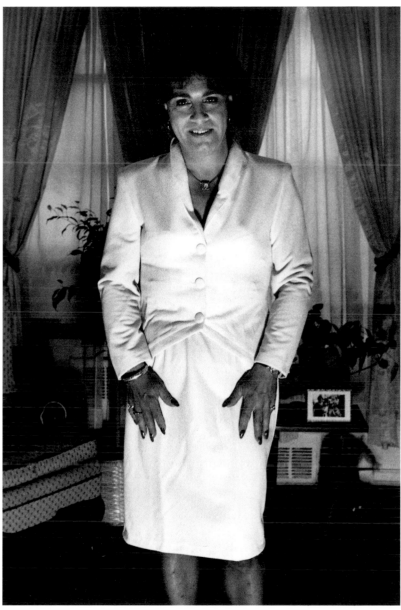

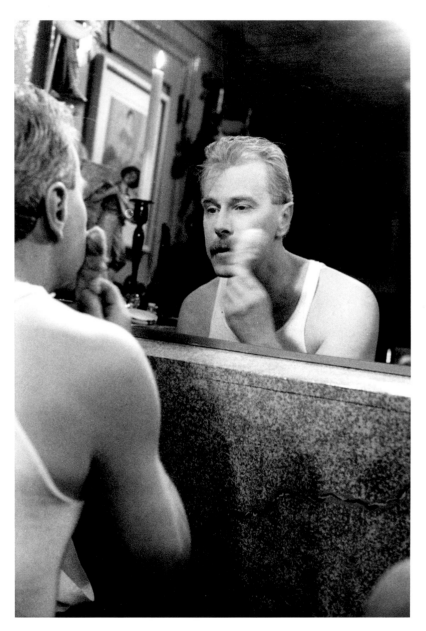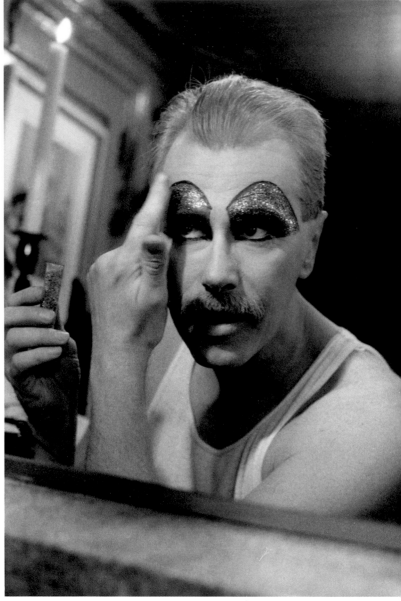

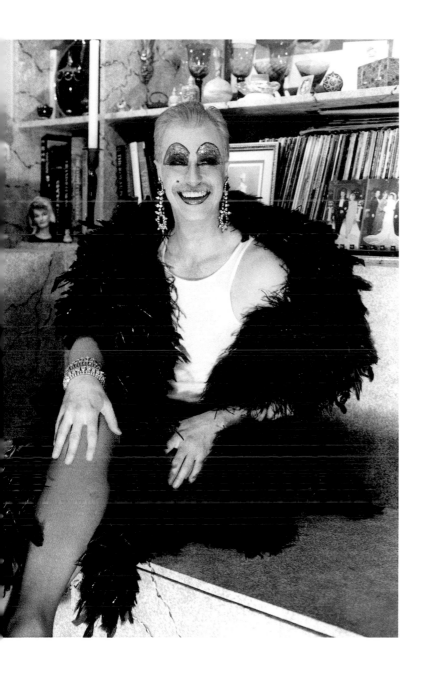

Luis/Lila

Transvestite

1988

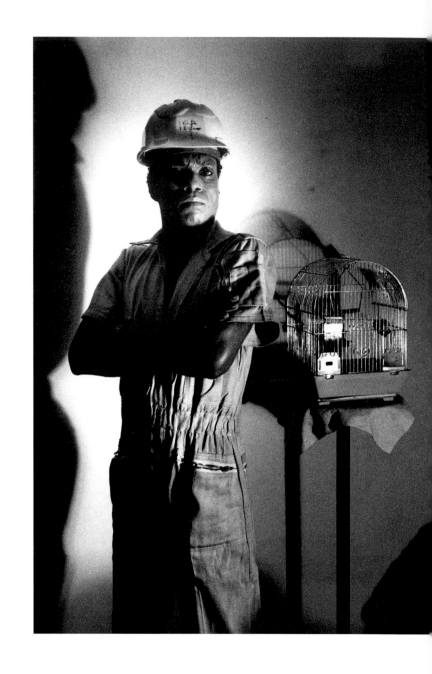

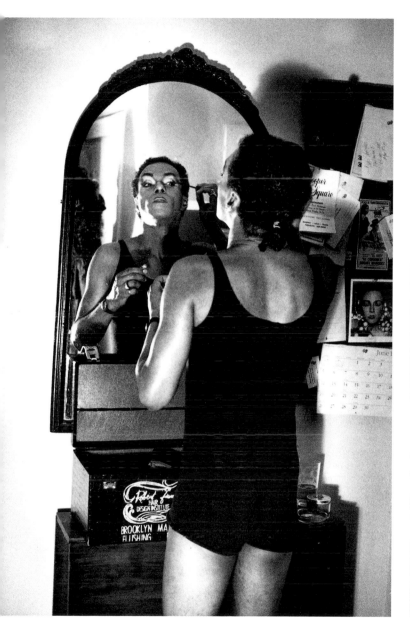
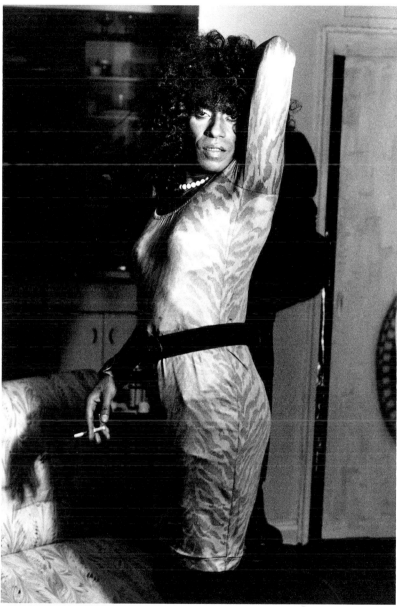

Joseph/Josie

Drag Queen

1989

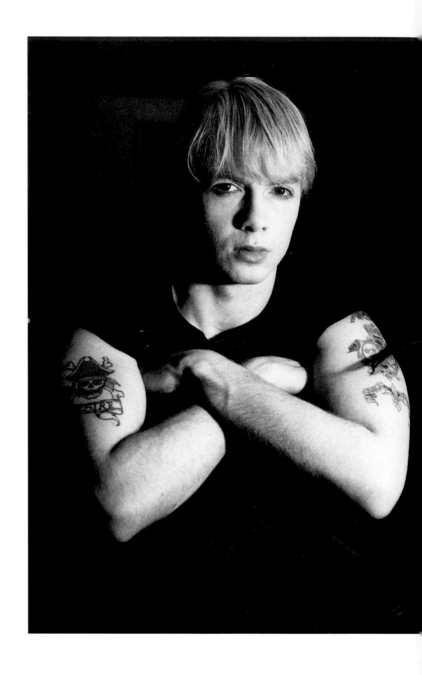

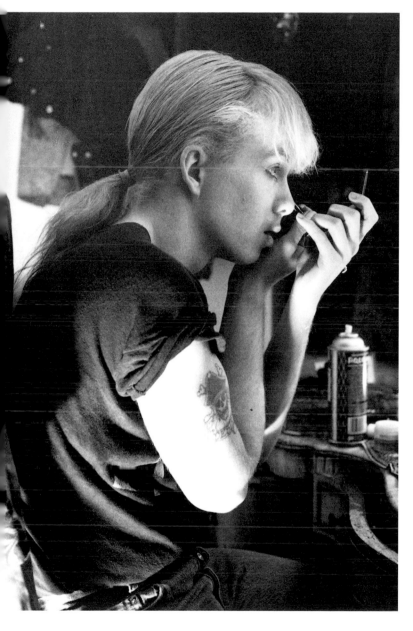
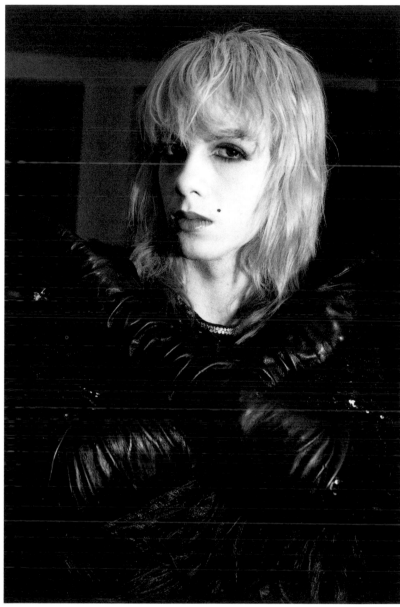

Barry/Vicky

Transvestite

1988

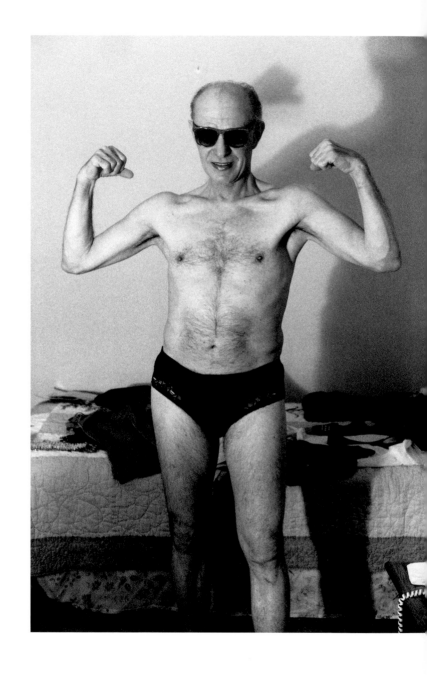

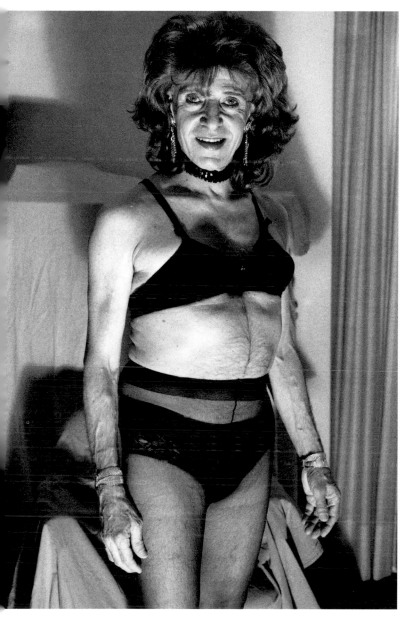
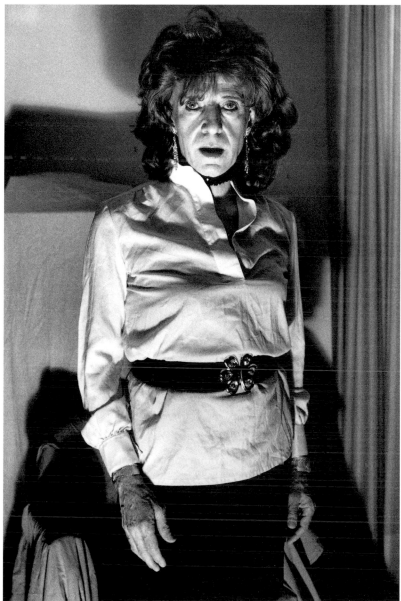

Brian/Ashley

Drag Queen

1989

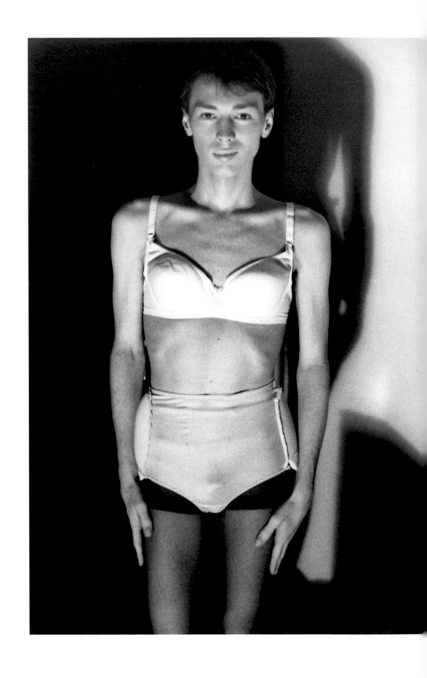

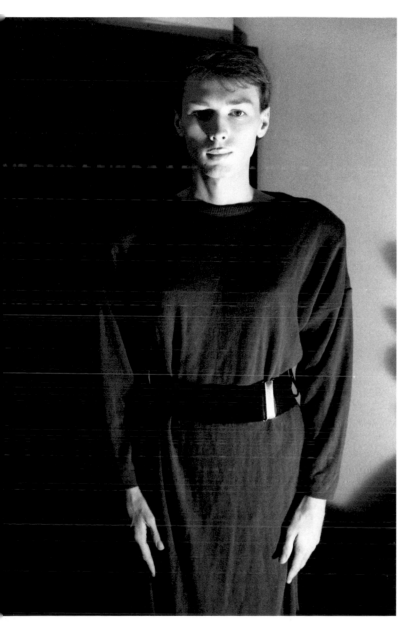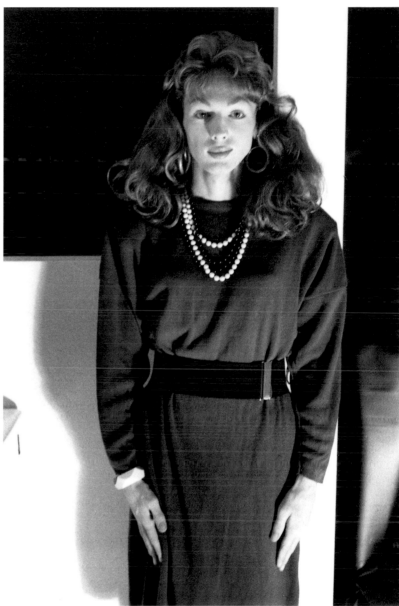

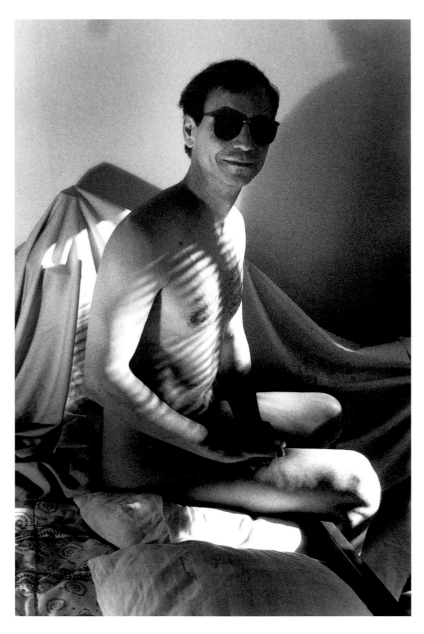
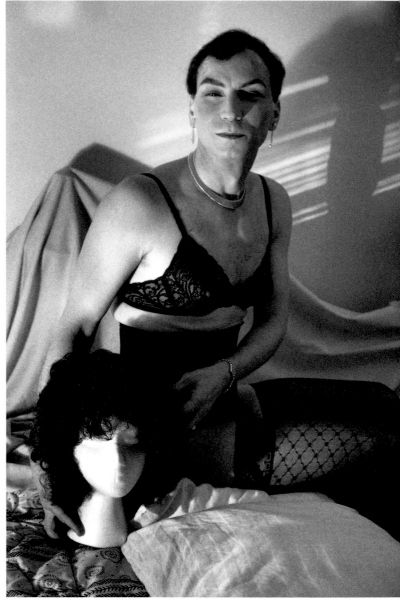

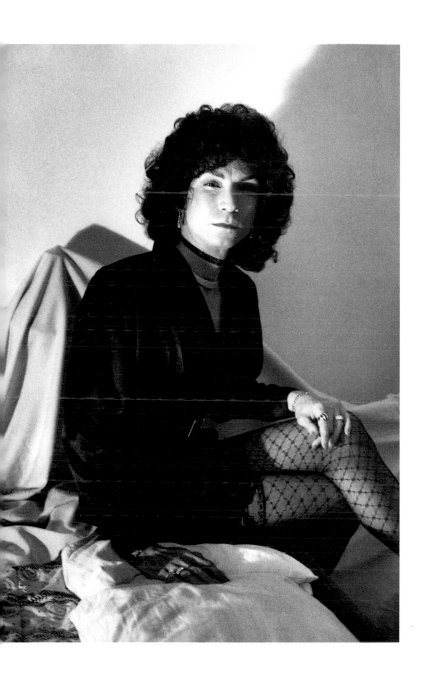

Dennis/Dede

Transvestite

1989

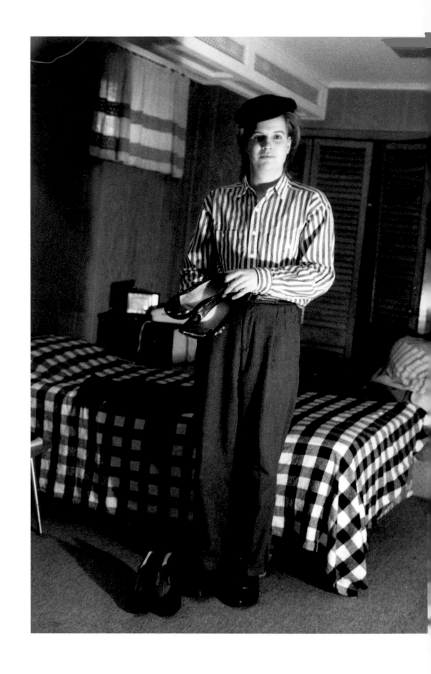

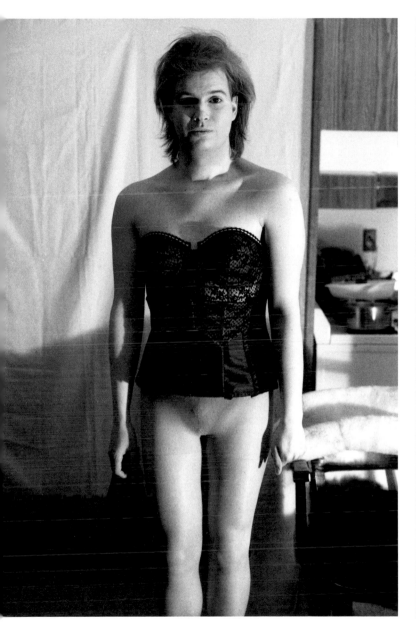
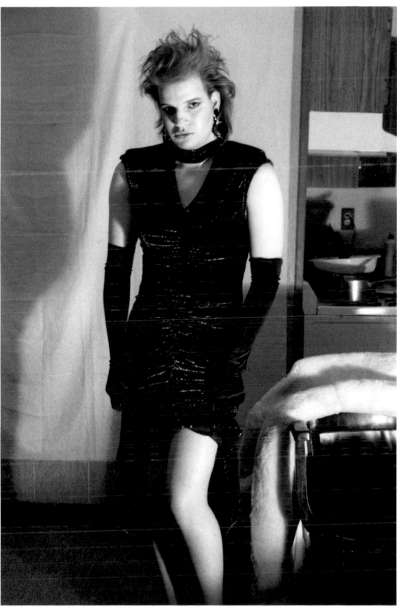

Ben/Camille

Drag Queen

1989

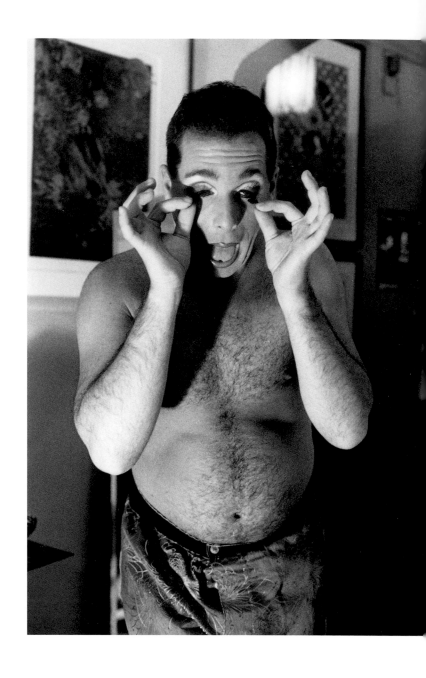

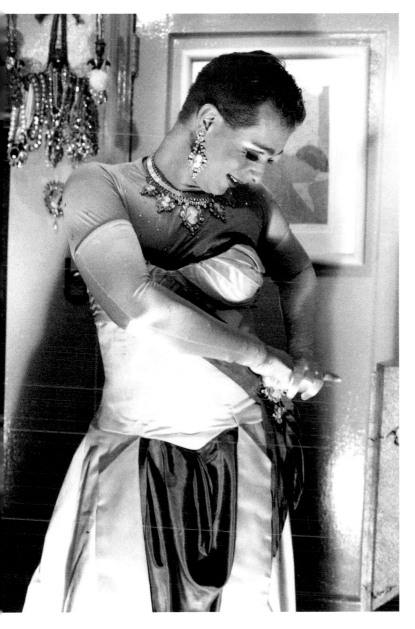

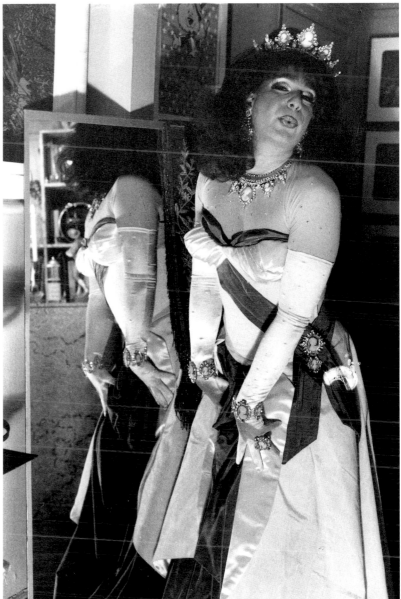

Brian/Miss April Fools

Drag Queen

1989

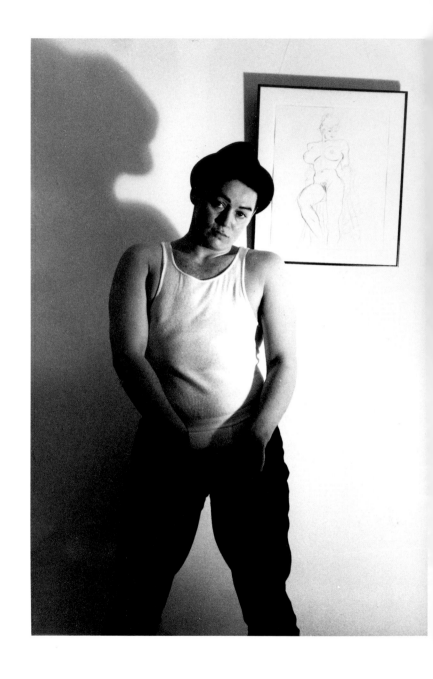

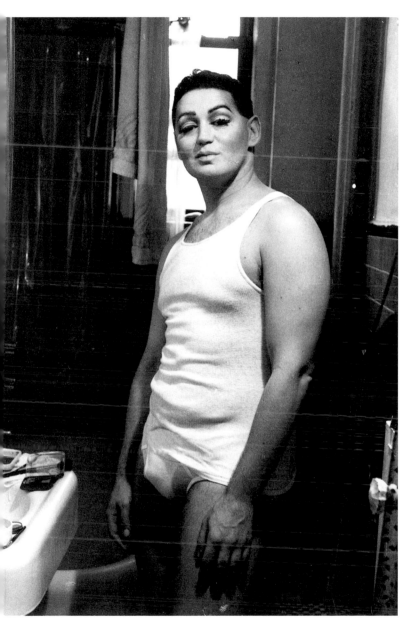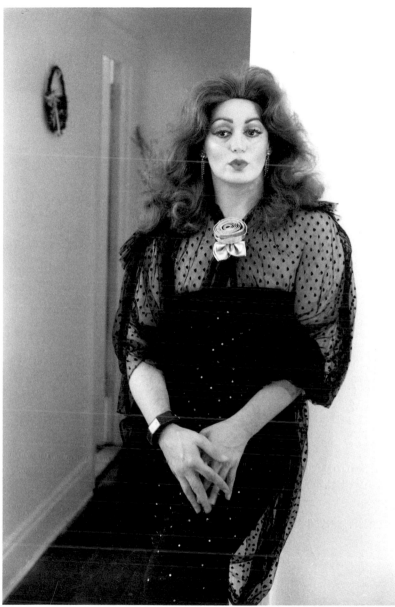

Joe/Honey

Drag Queen

1989

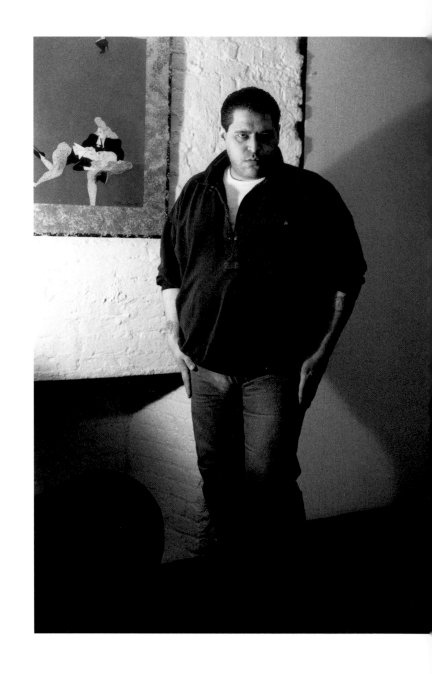

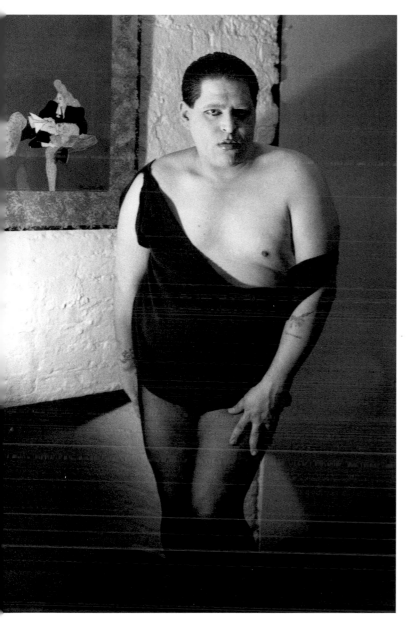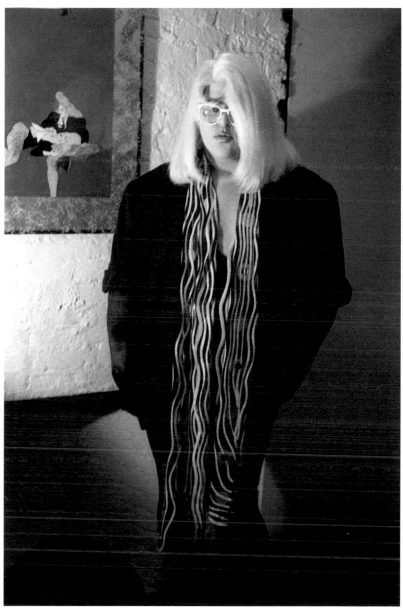

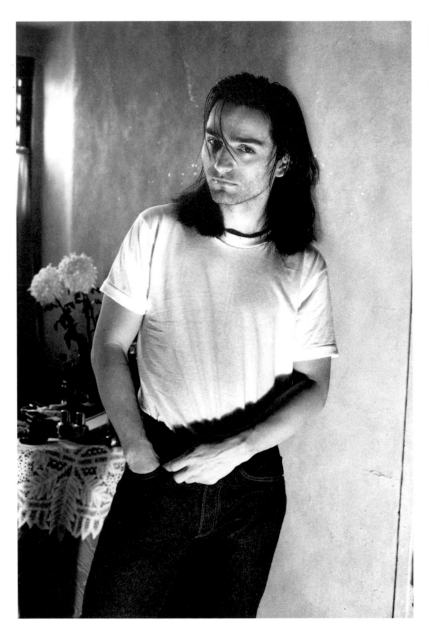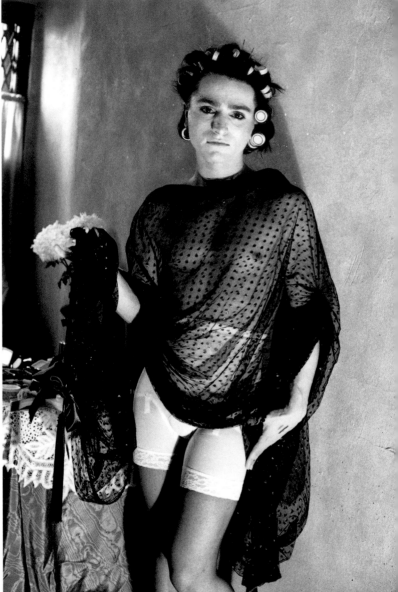

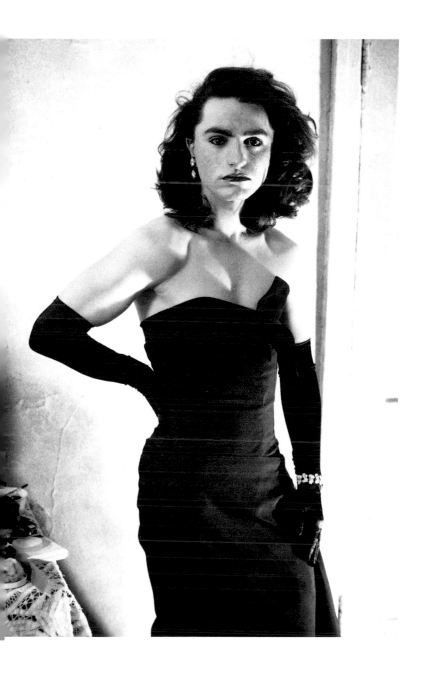

Peter/Paulina

Drag Queen

1989

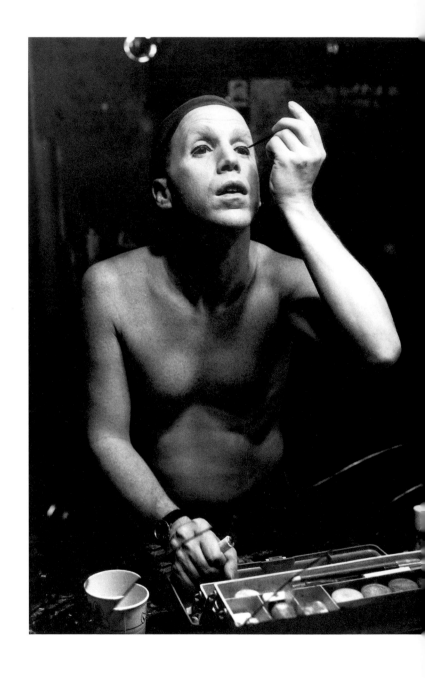

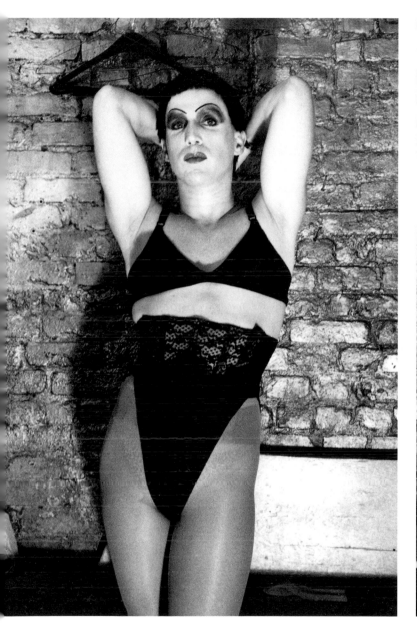
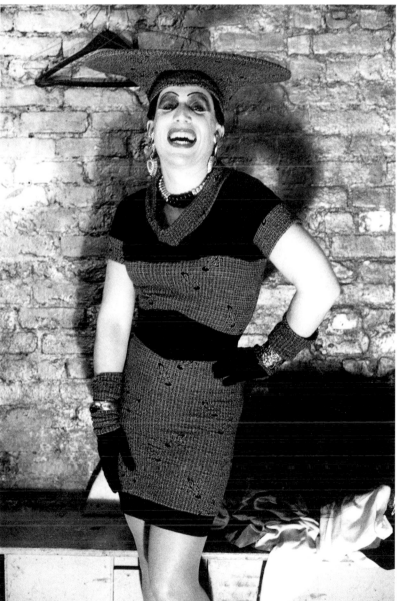

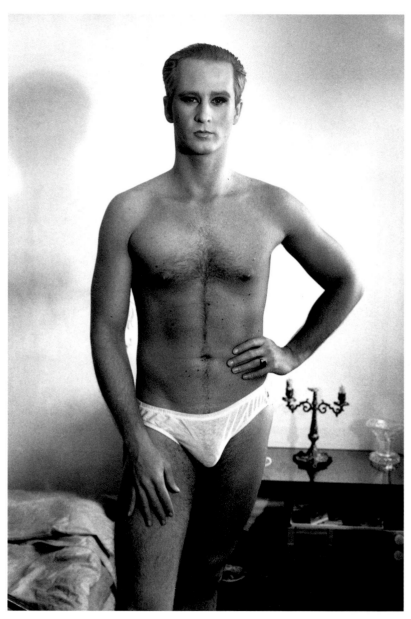
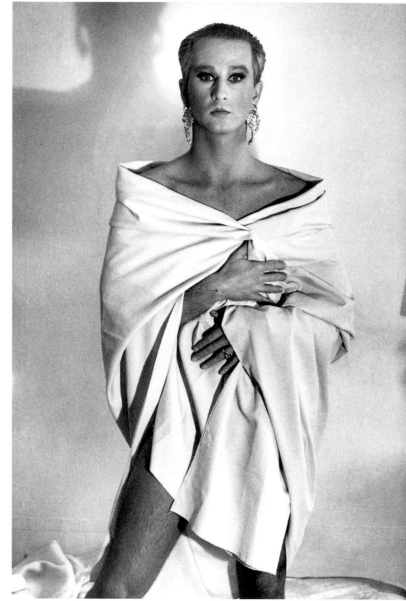

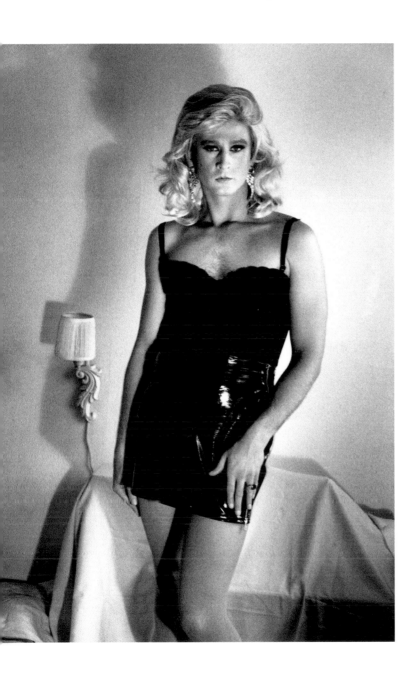

Bernard/Olympia

Drag Queen

1988

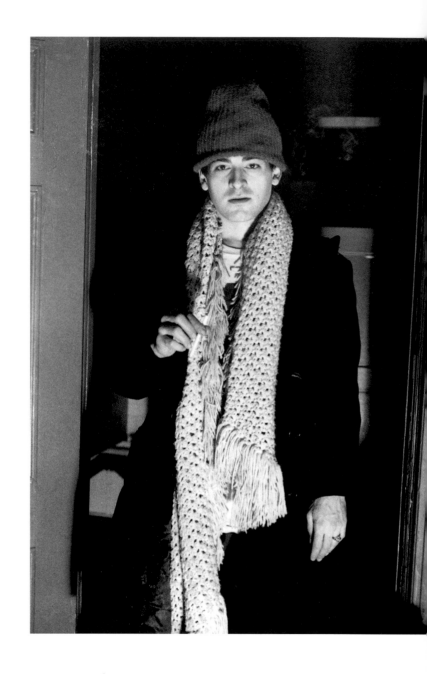

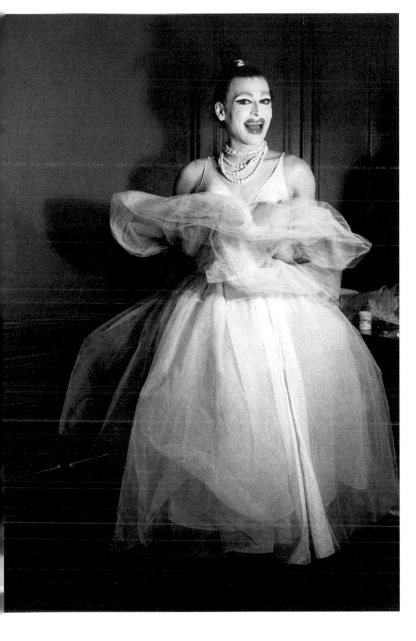
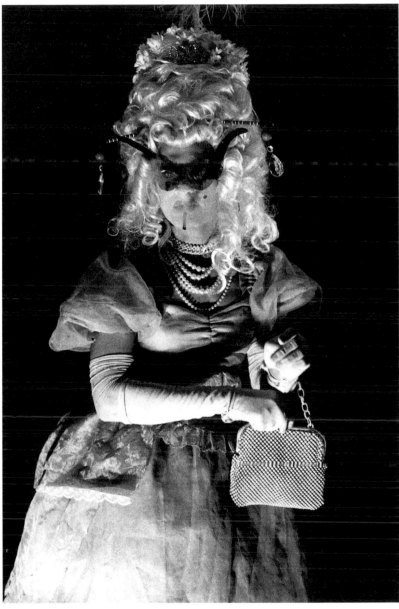

Tony / Toni

Transvestite

1989

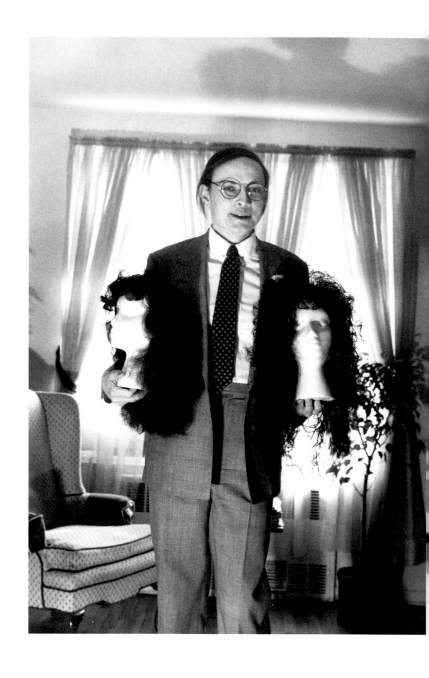

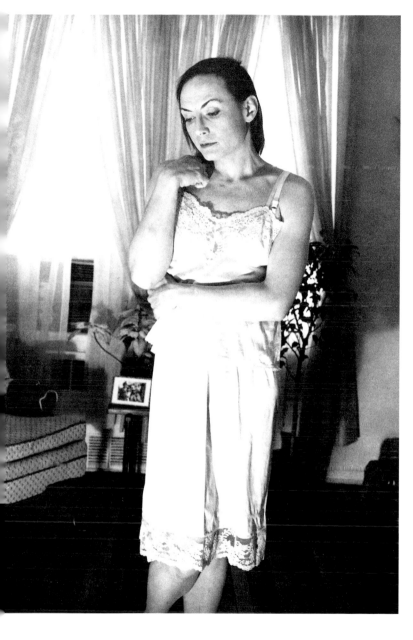
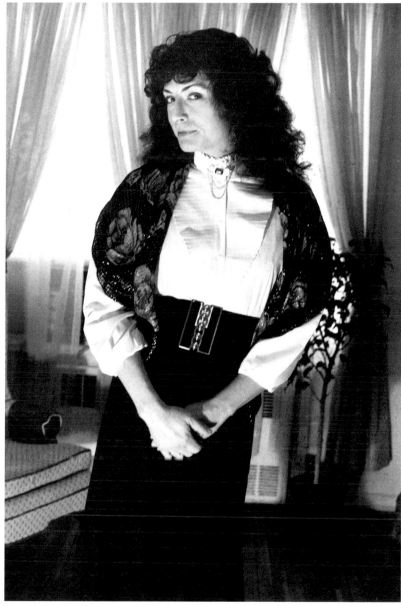

Lithgow/Lady L

Drag Queen

1989

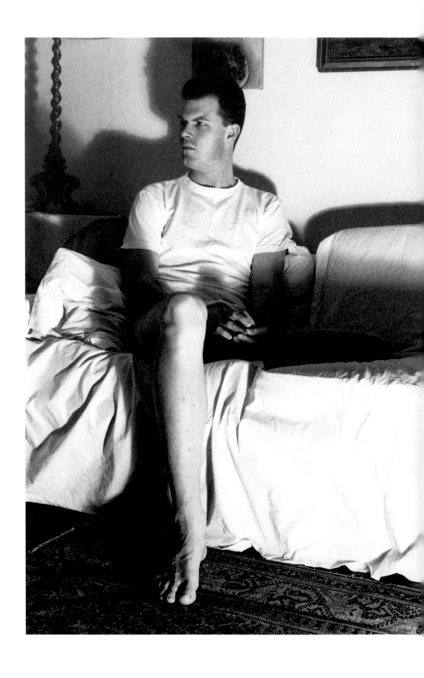

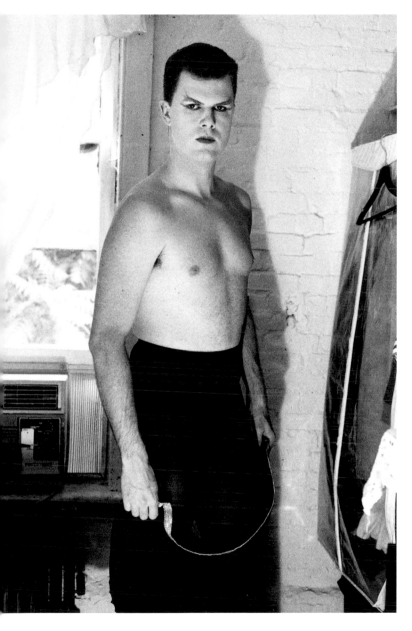
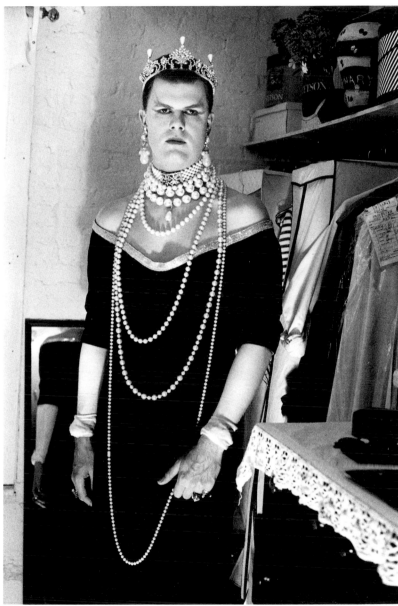

John/Dixie

Drag Queen

1988

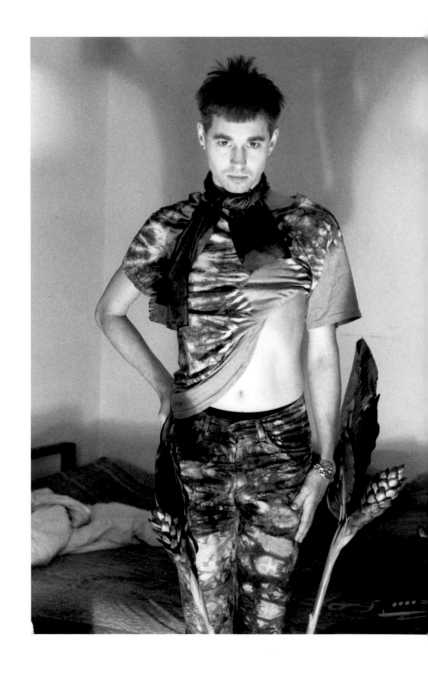

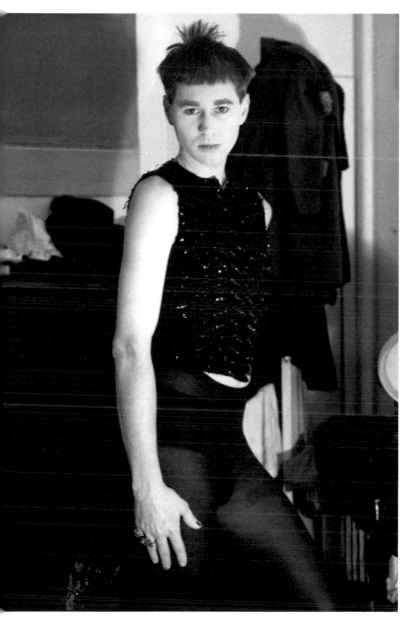
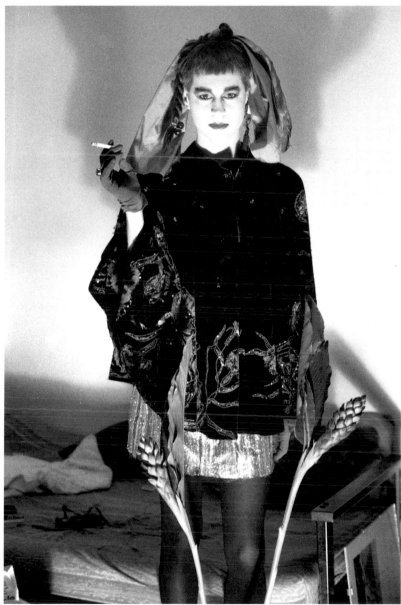

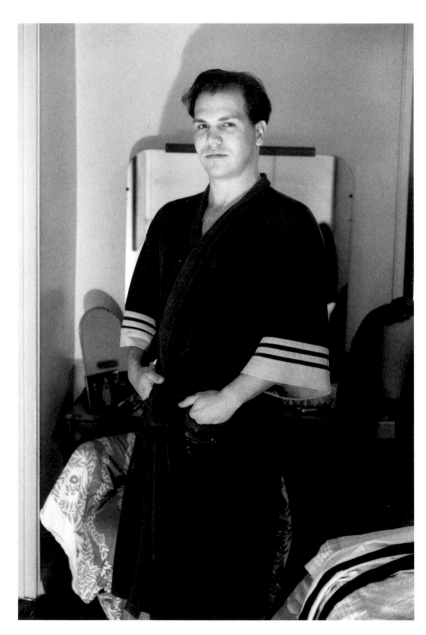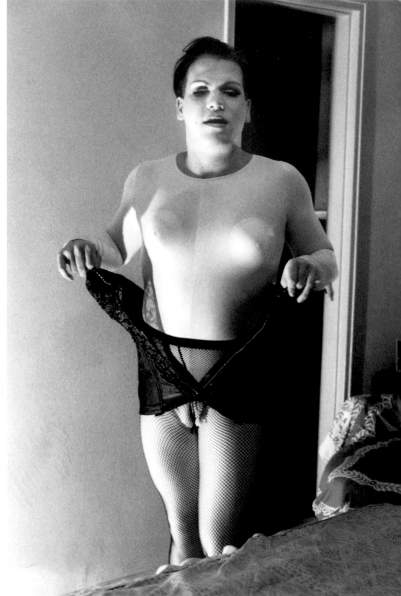

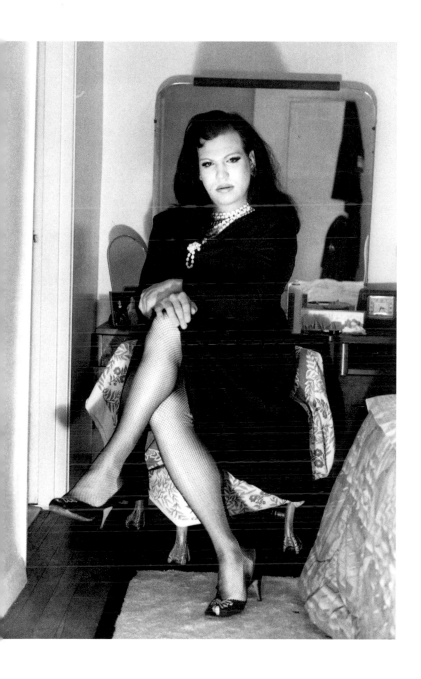

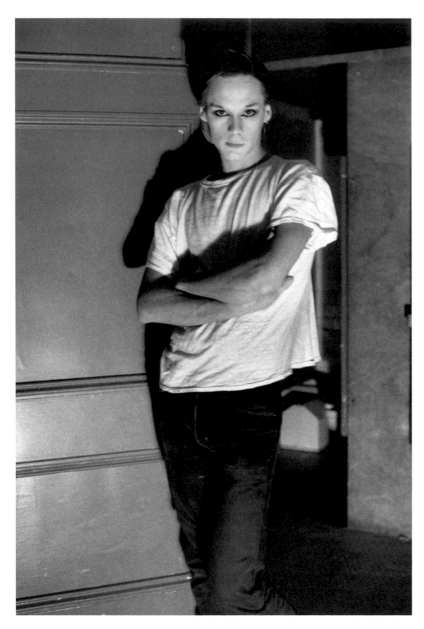

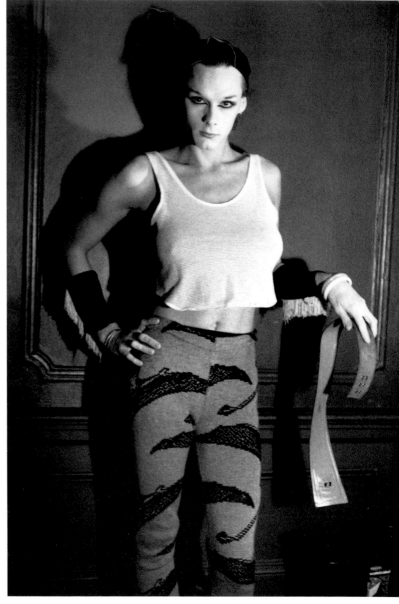

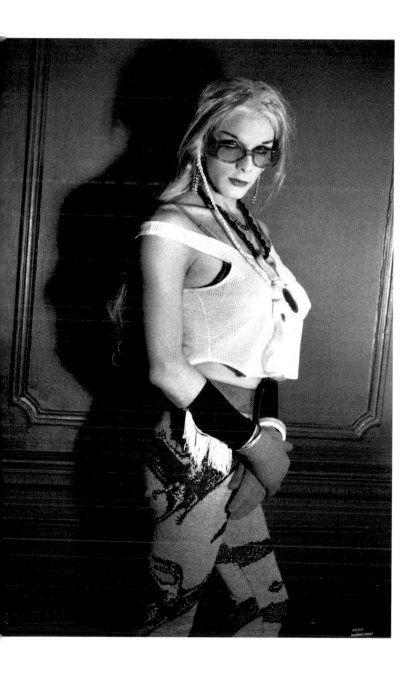

Scott/Mavis Davis
Drag Queen
1988

Terance/Terance in a dress

Drag Queen

1989

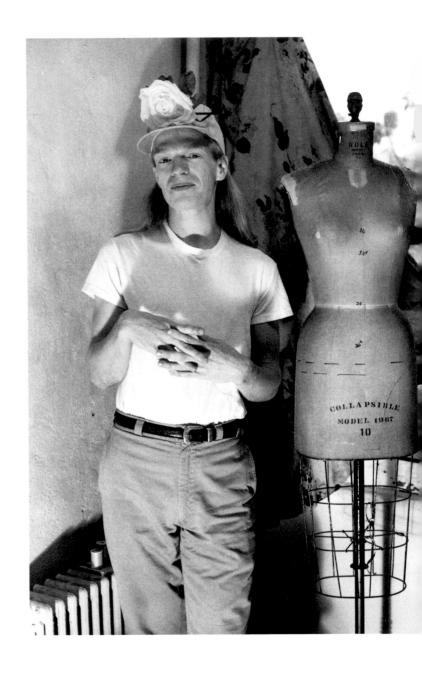

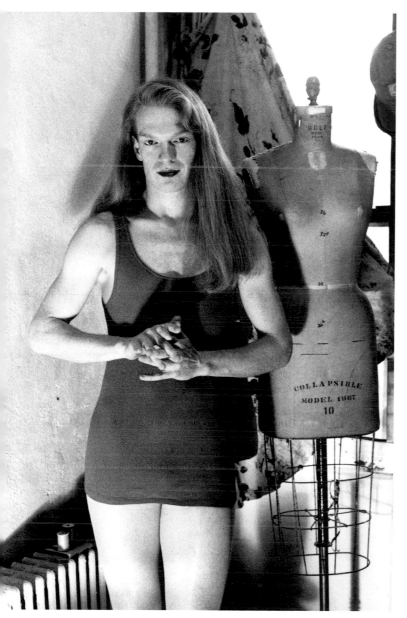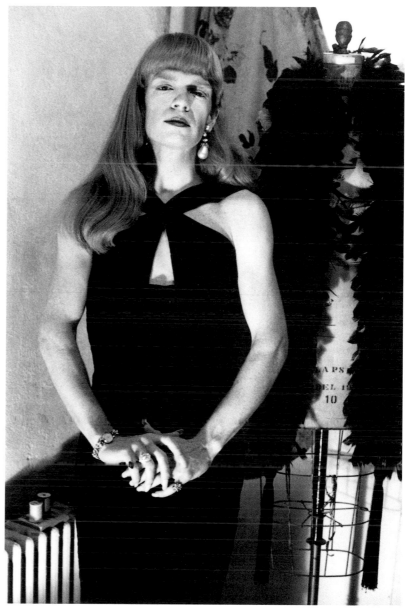

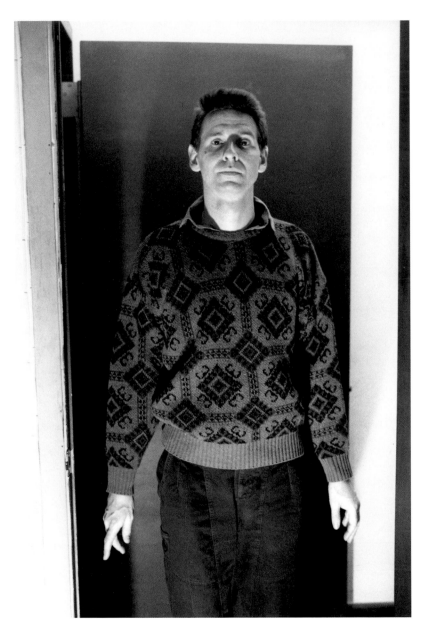
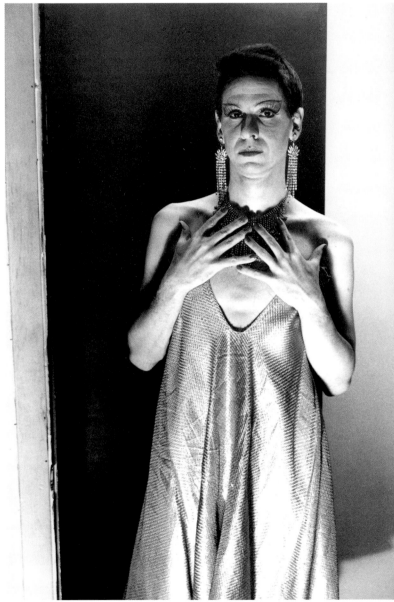

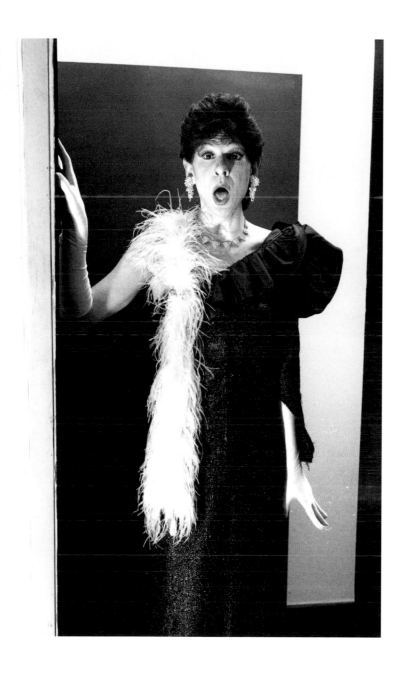

Codie/Sister Cody Ravioli

Drag Queen

1989

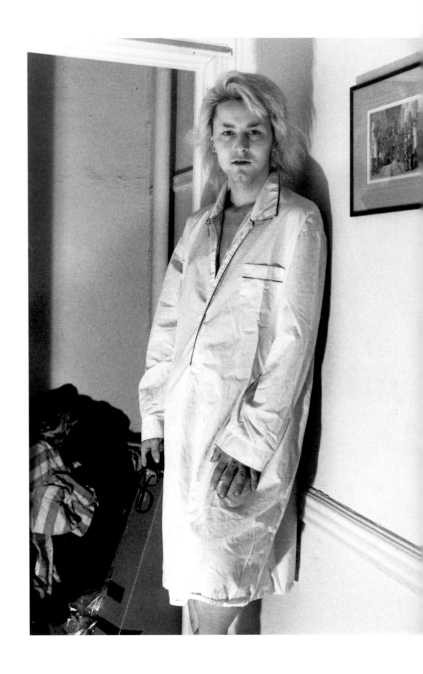

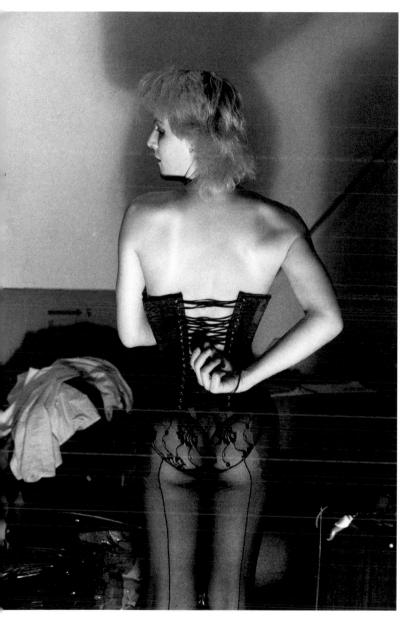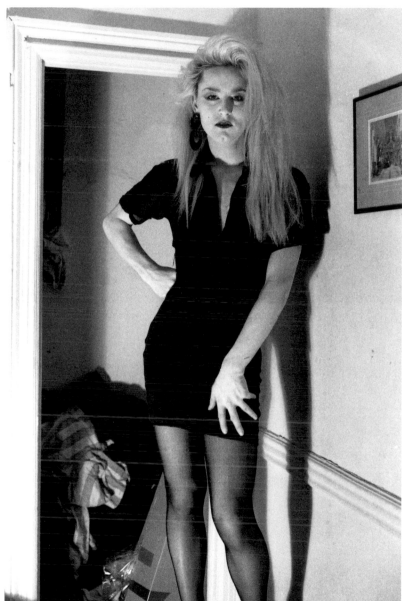

TRANSSEXUALS

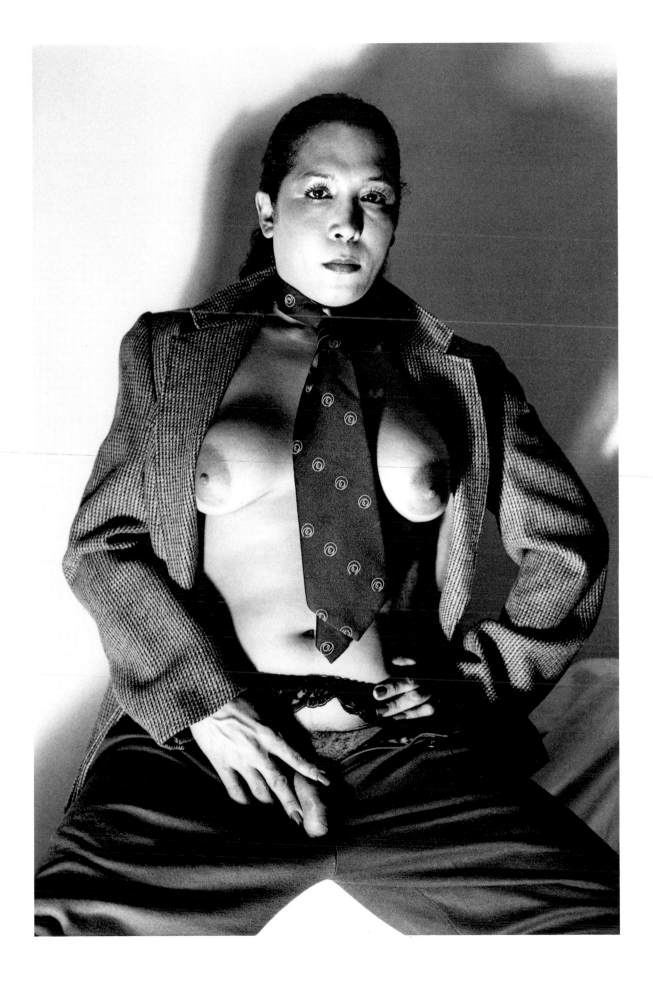

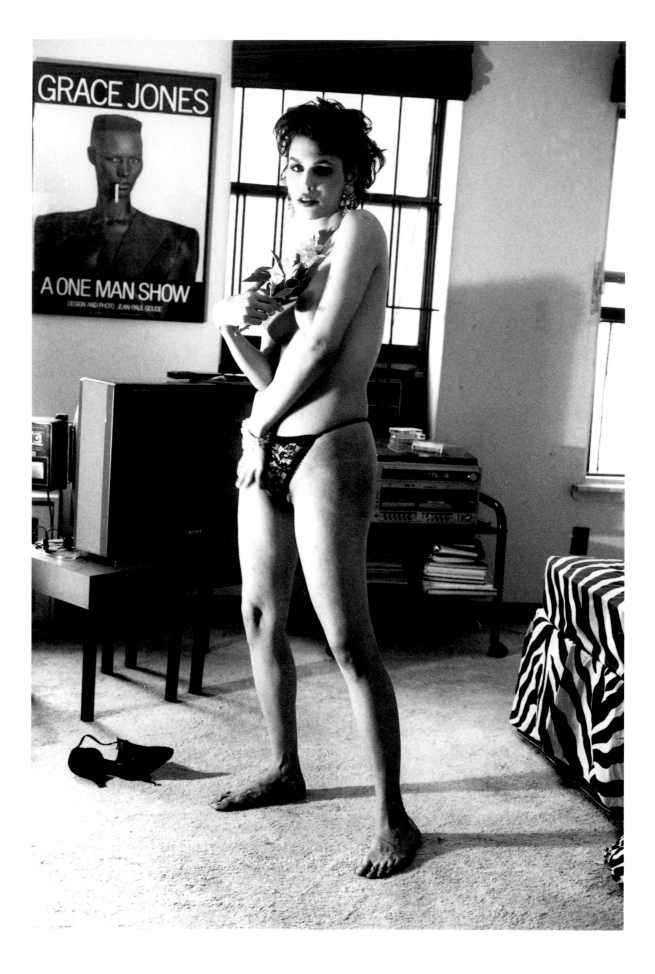

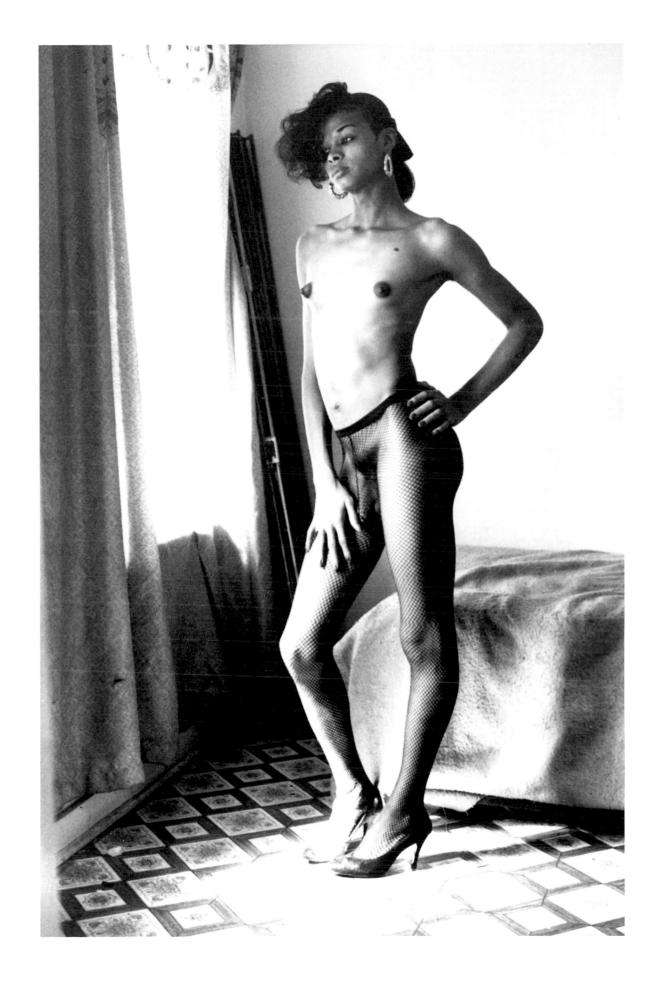

Chiffon
1986

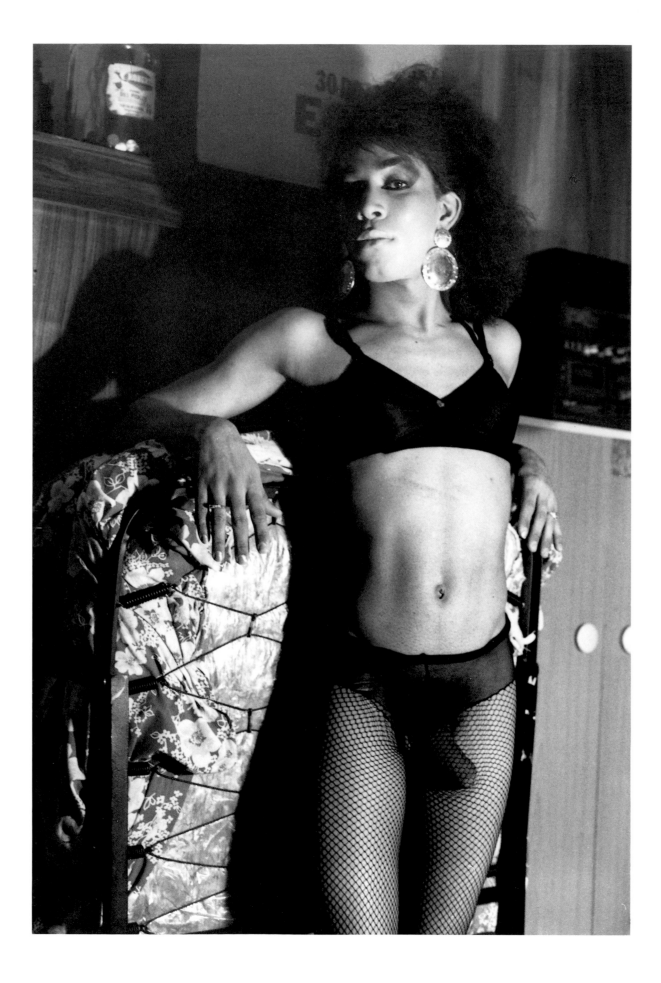

Coco
1987

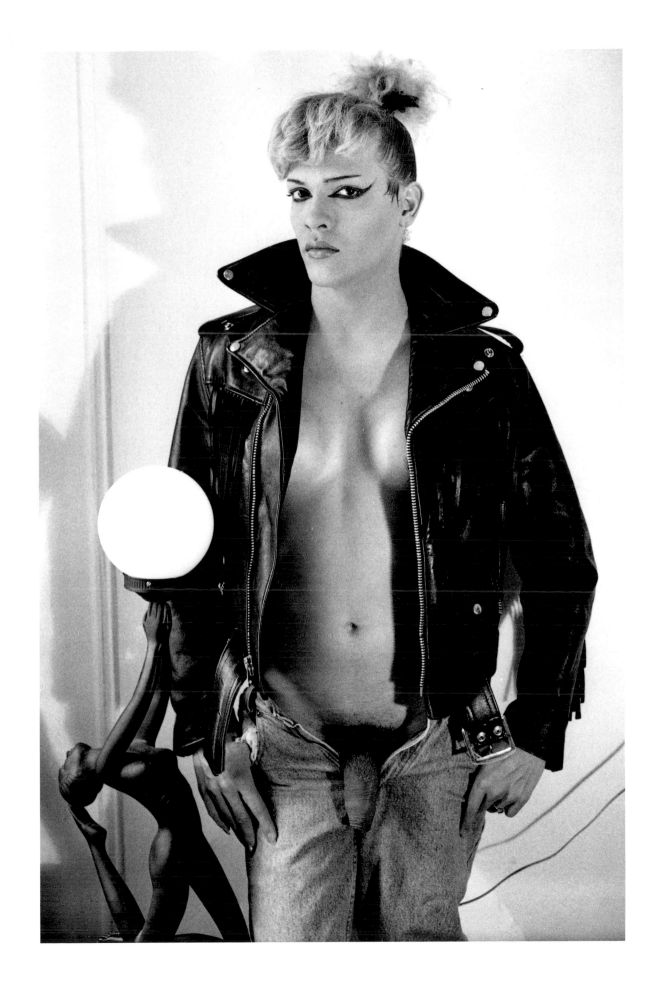

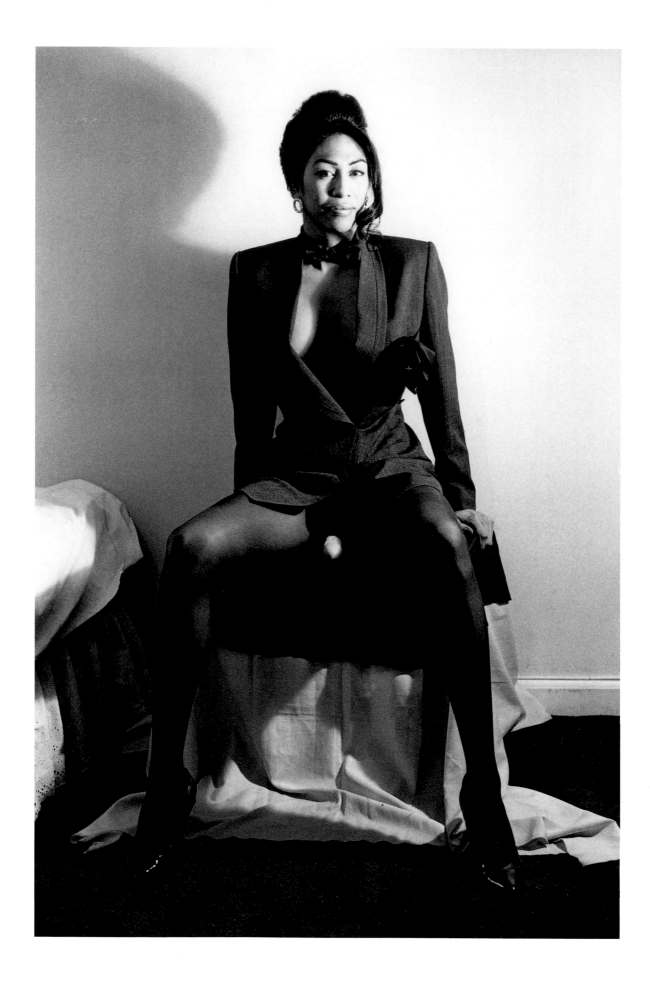

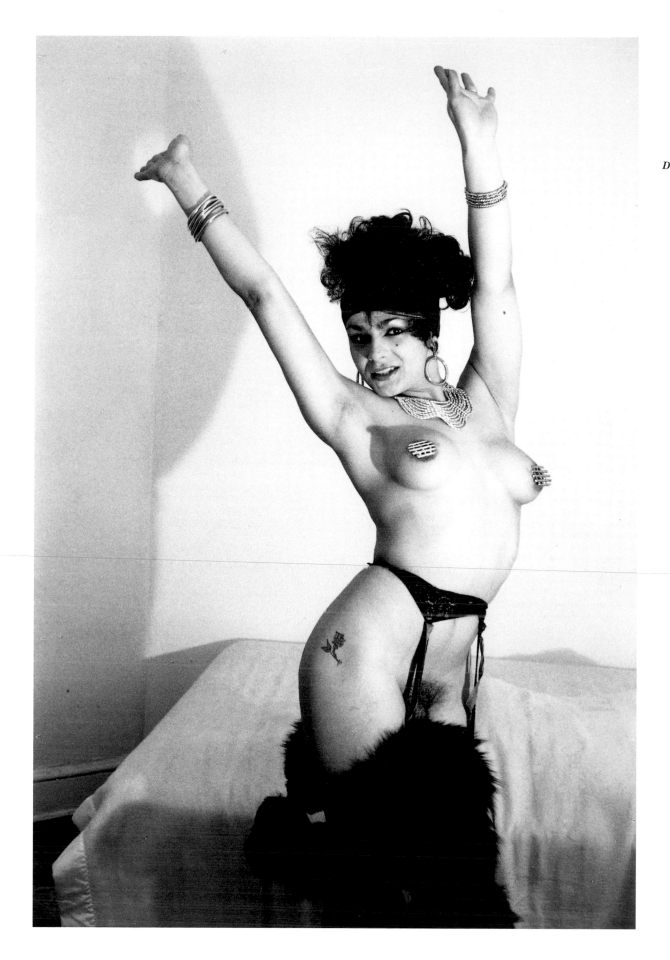

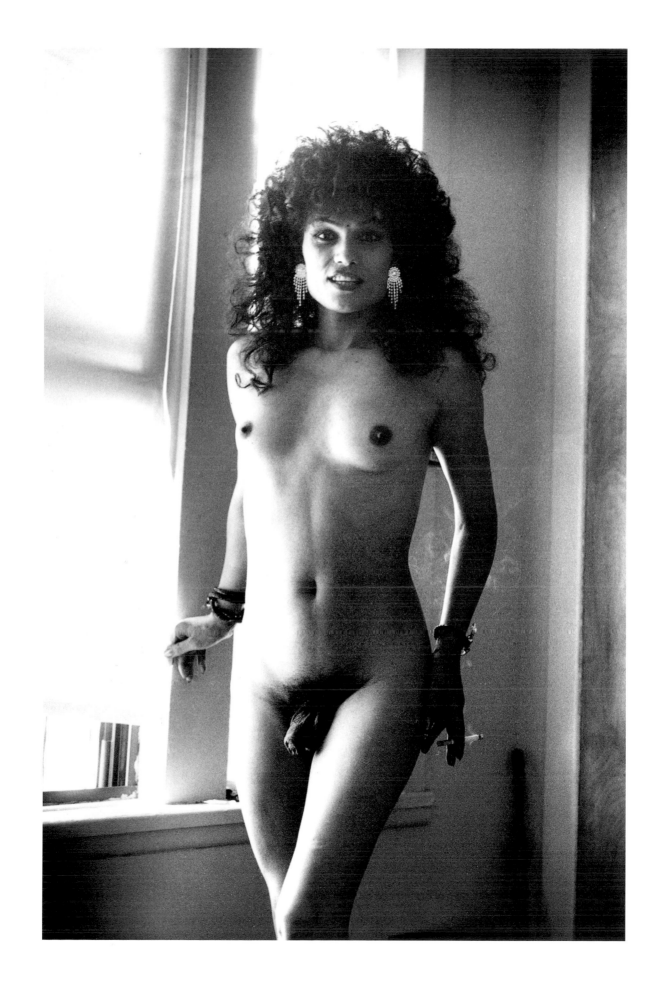

Sylvia

1986

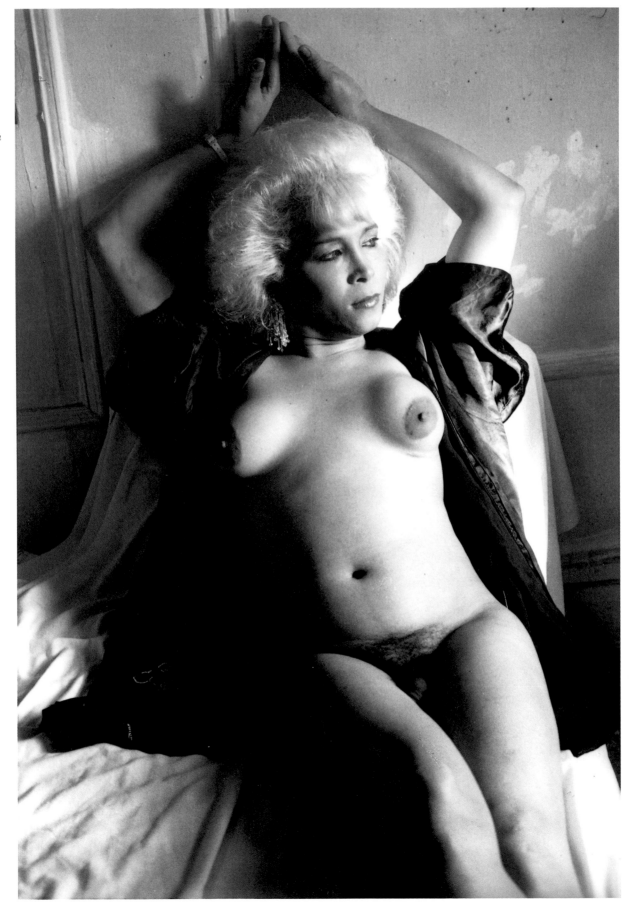

Nastasha

1987

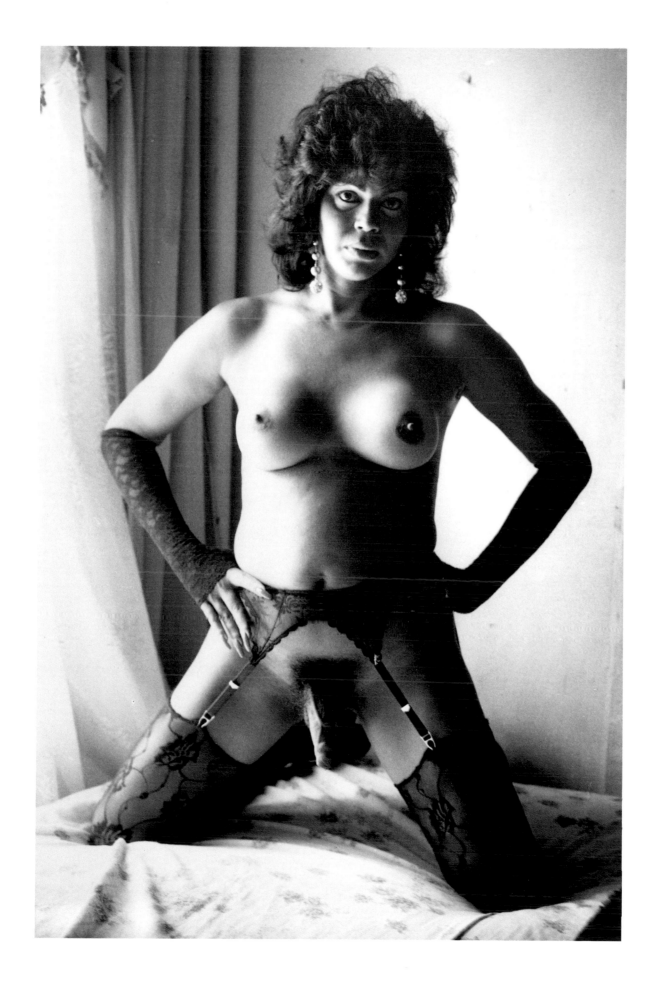

Alexis
1986

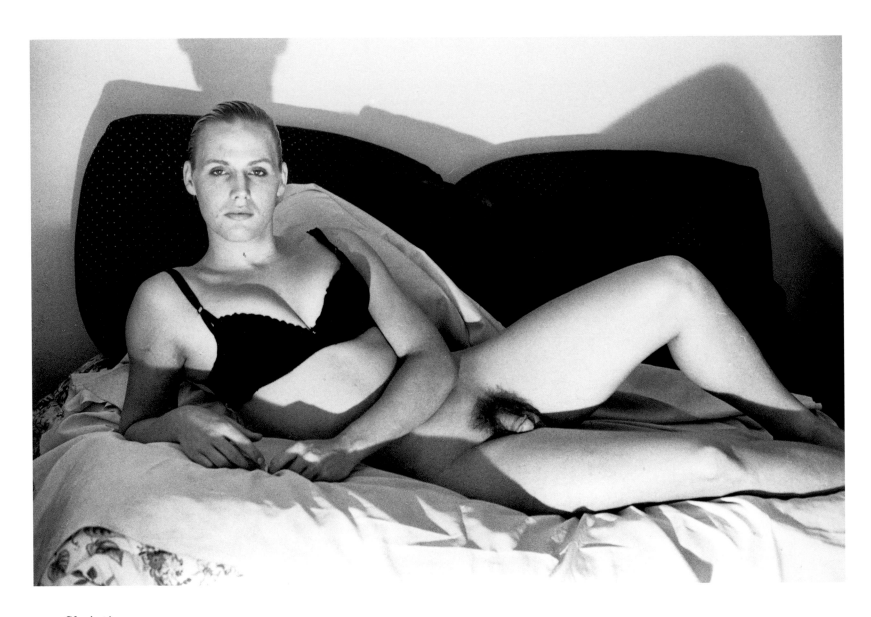

Christine

1992

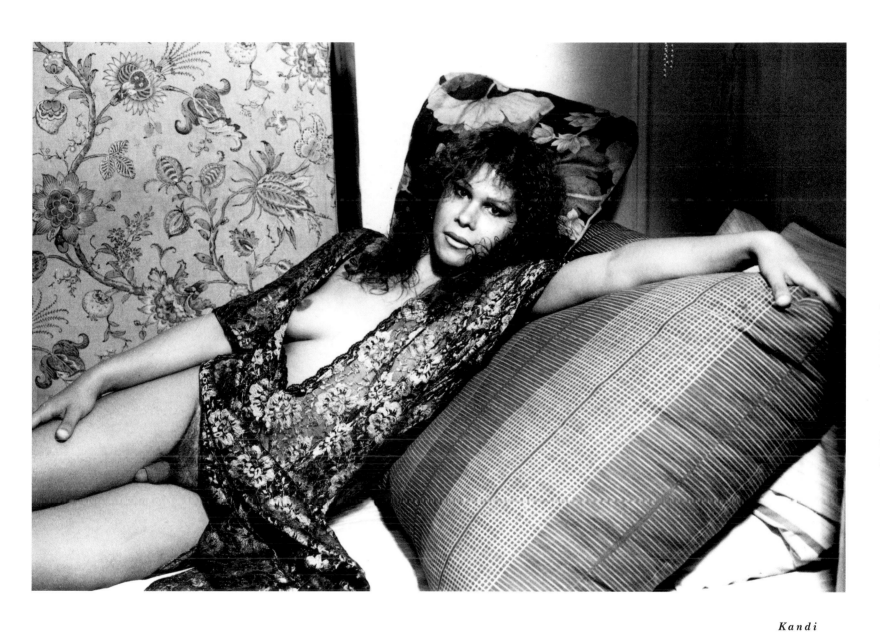

Kandi

1986

Angie

1987

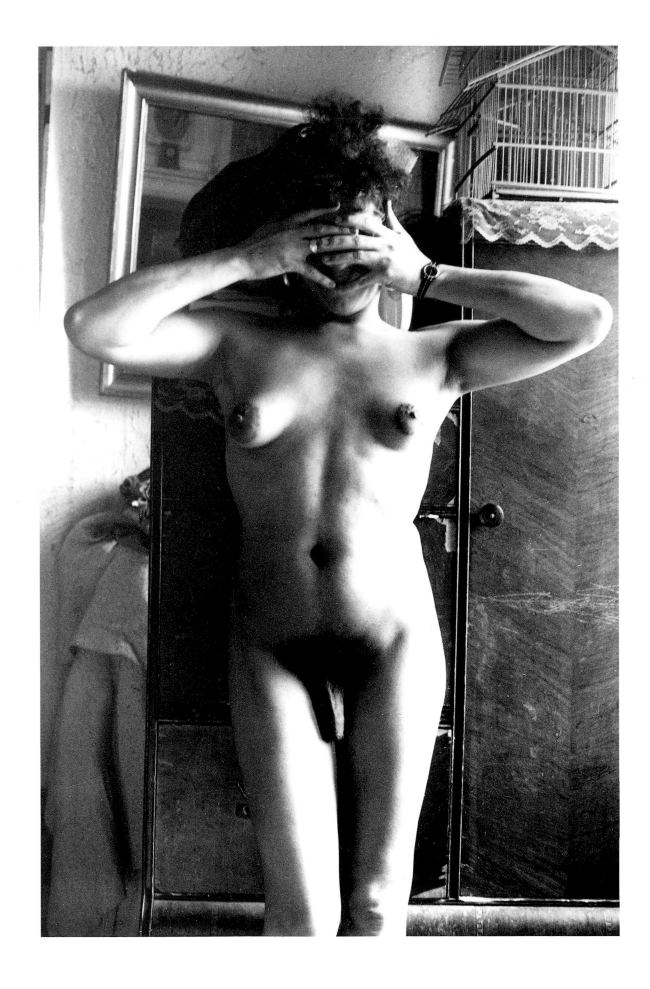

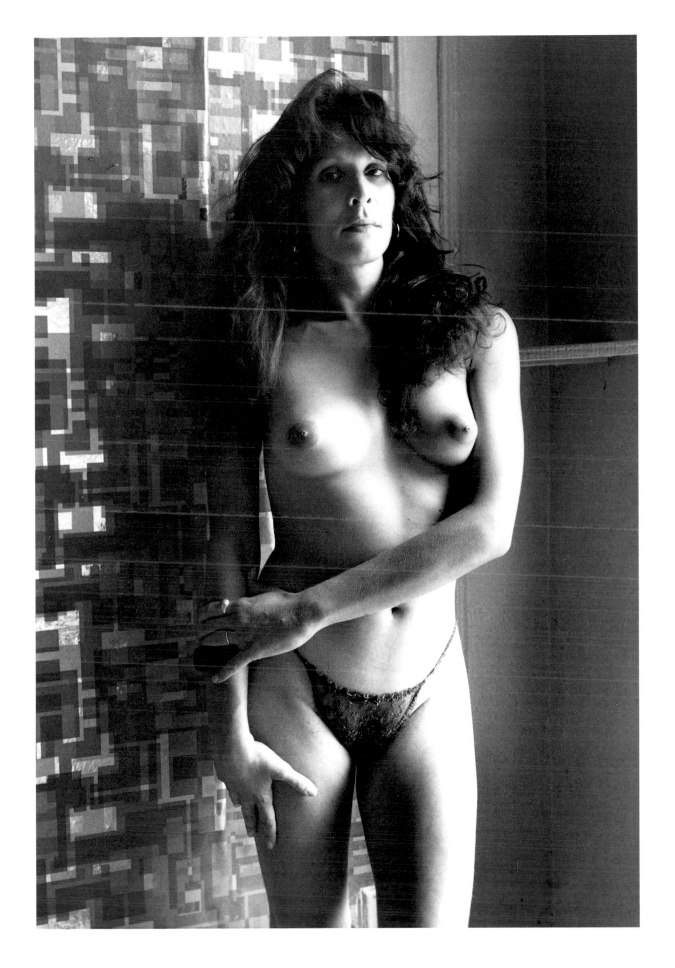

Sally
1986

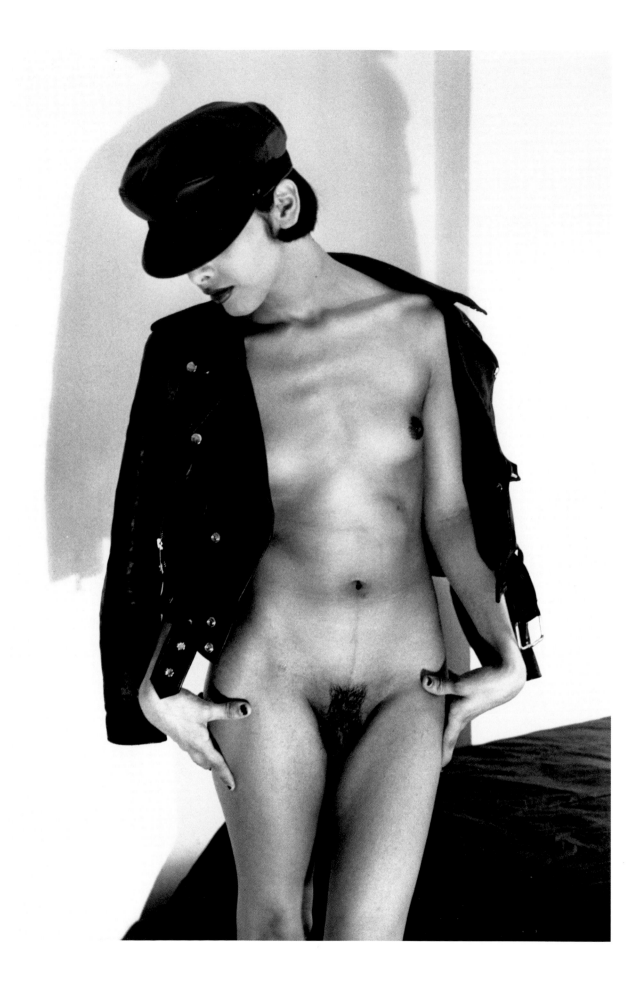

Yvette
1992

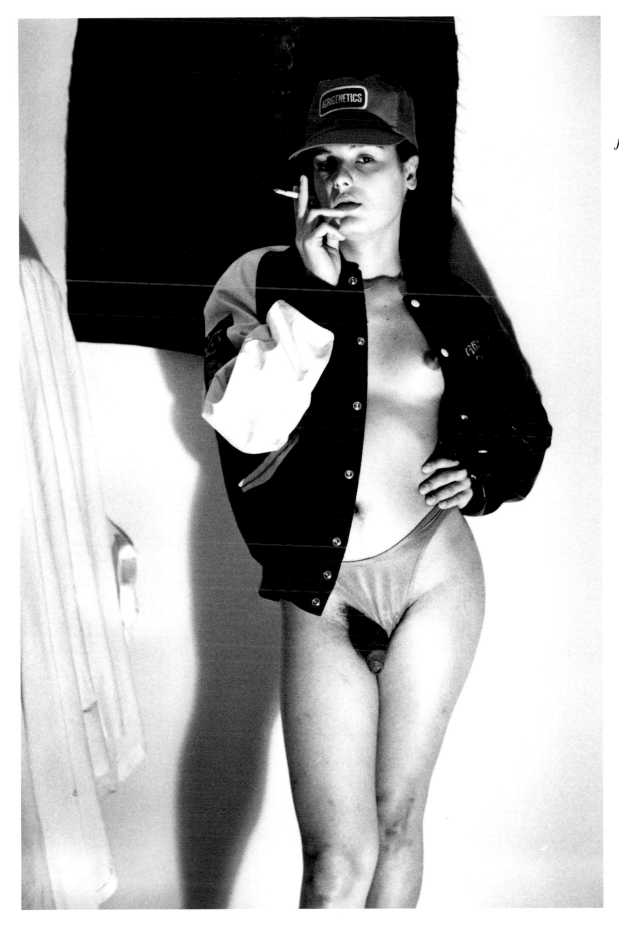

Jennifer
1987

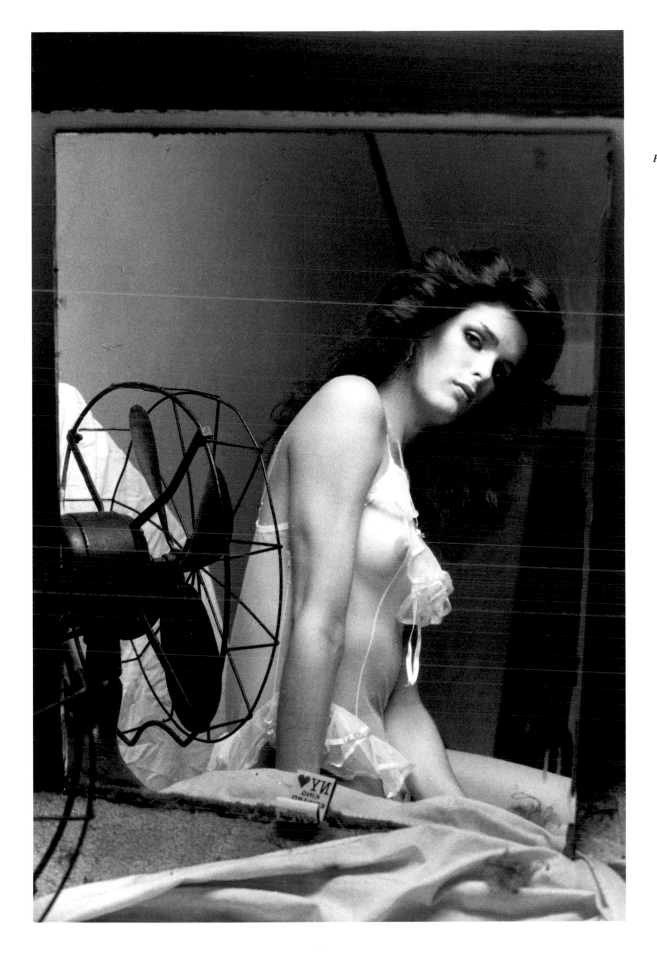

Sylvia
Tina
1992

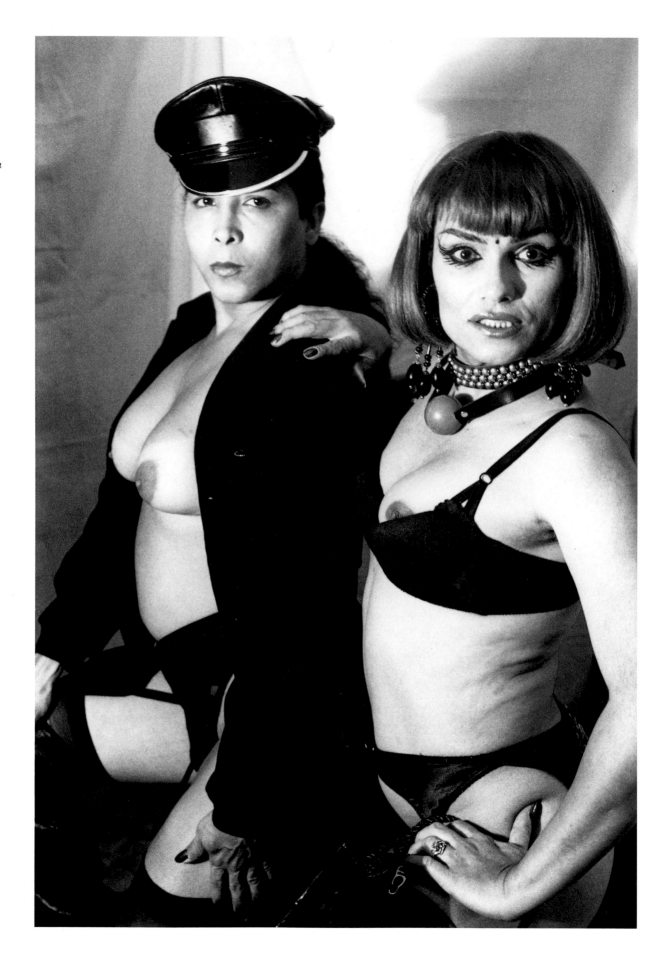

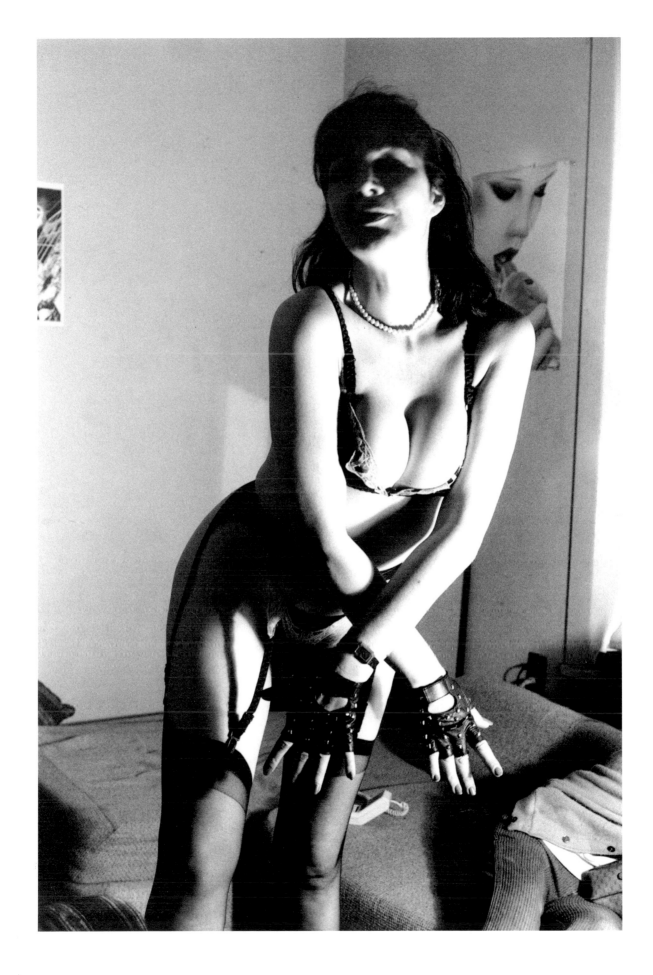

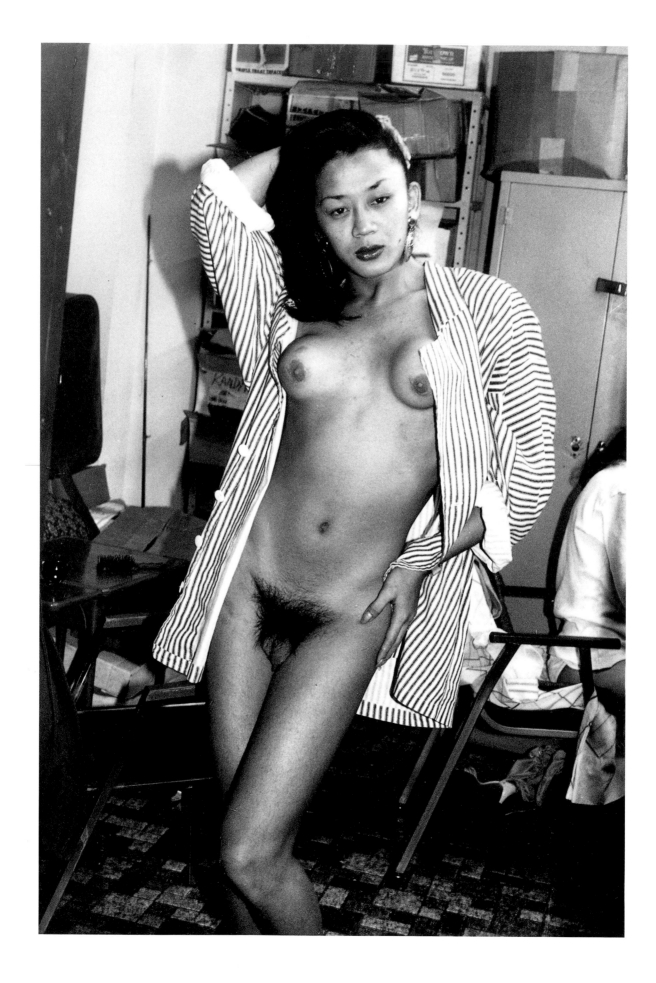

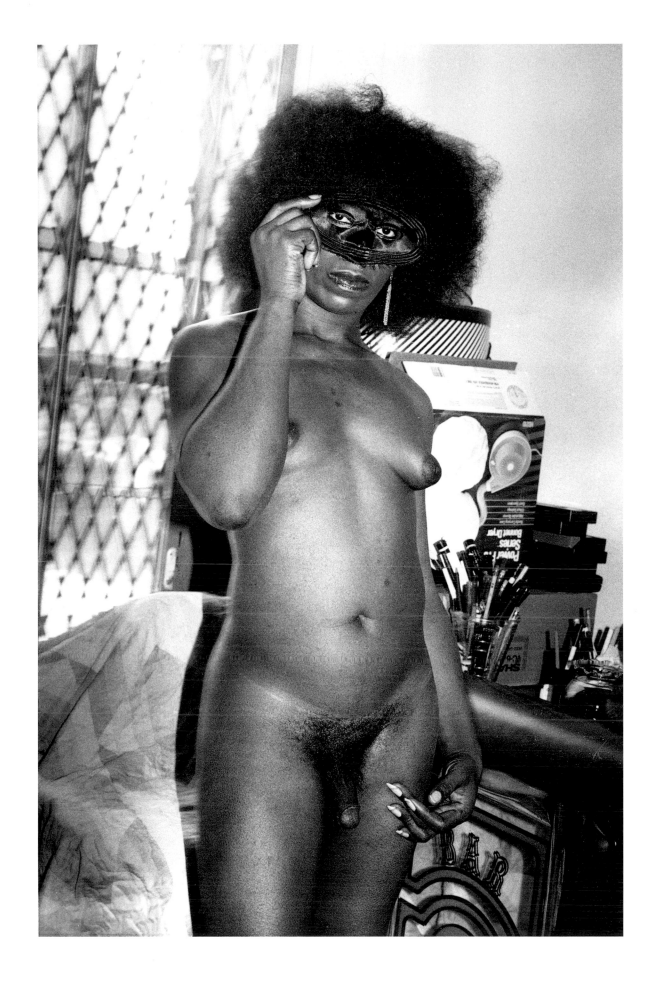

Denise
1986

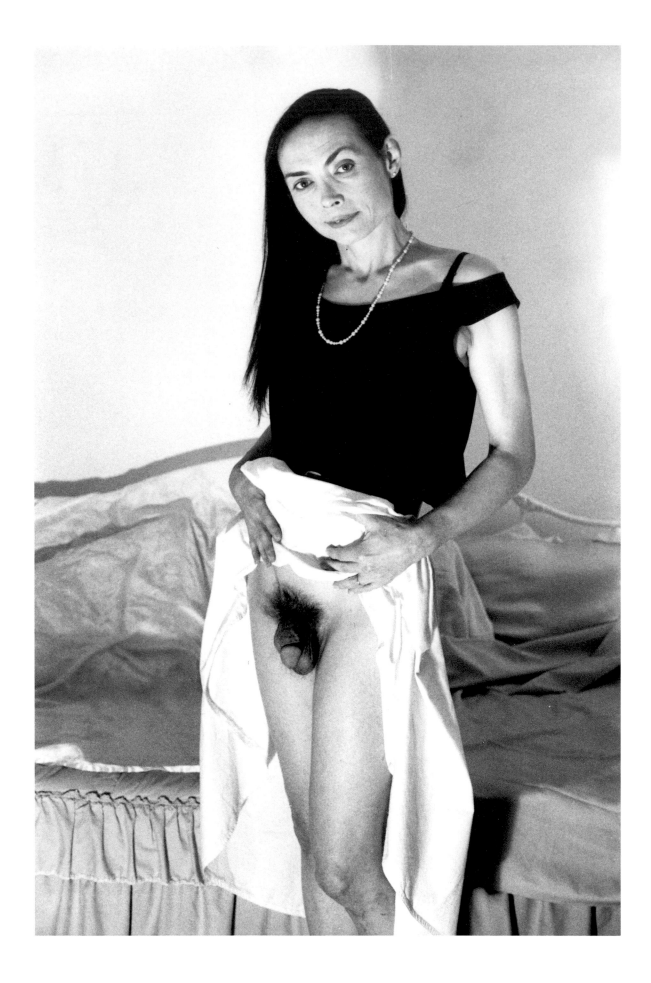

Toni
1991

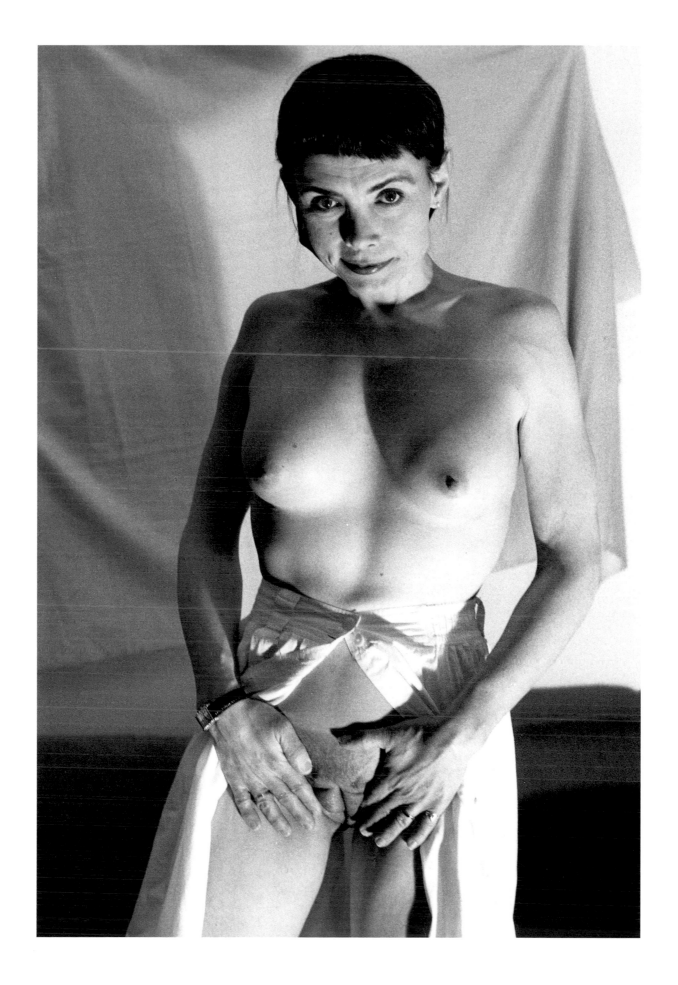

Toni
1992

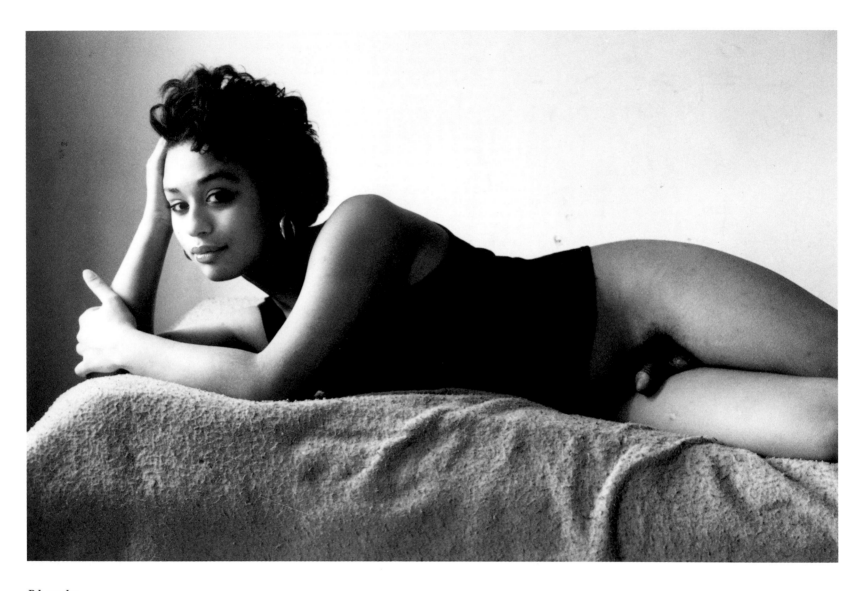

Rhonda

1986

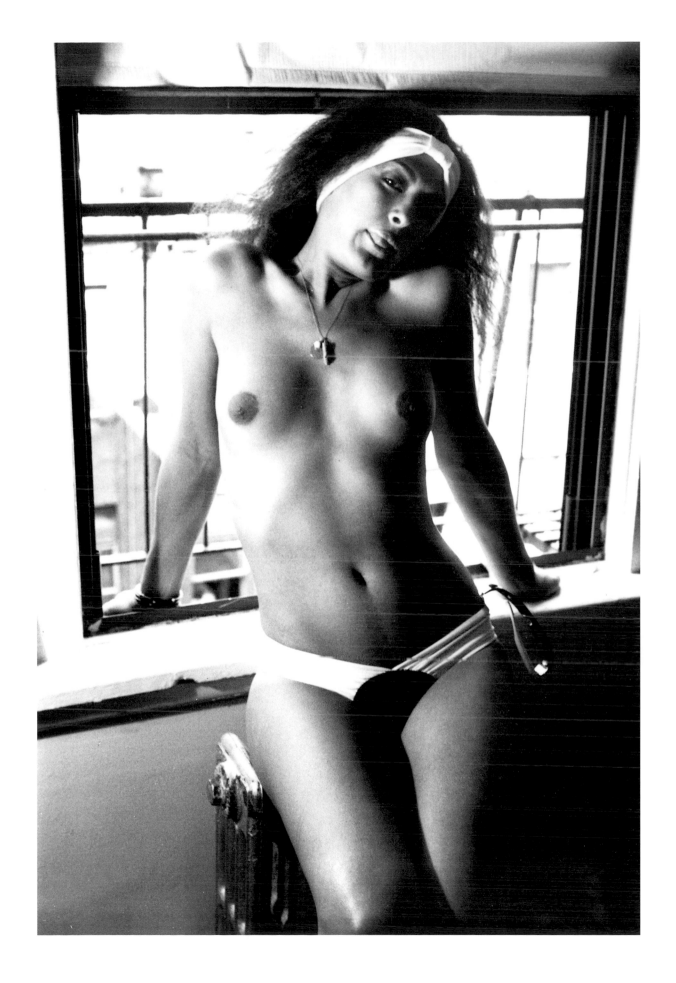

Tina
1986

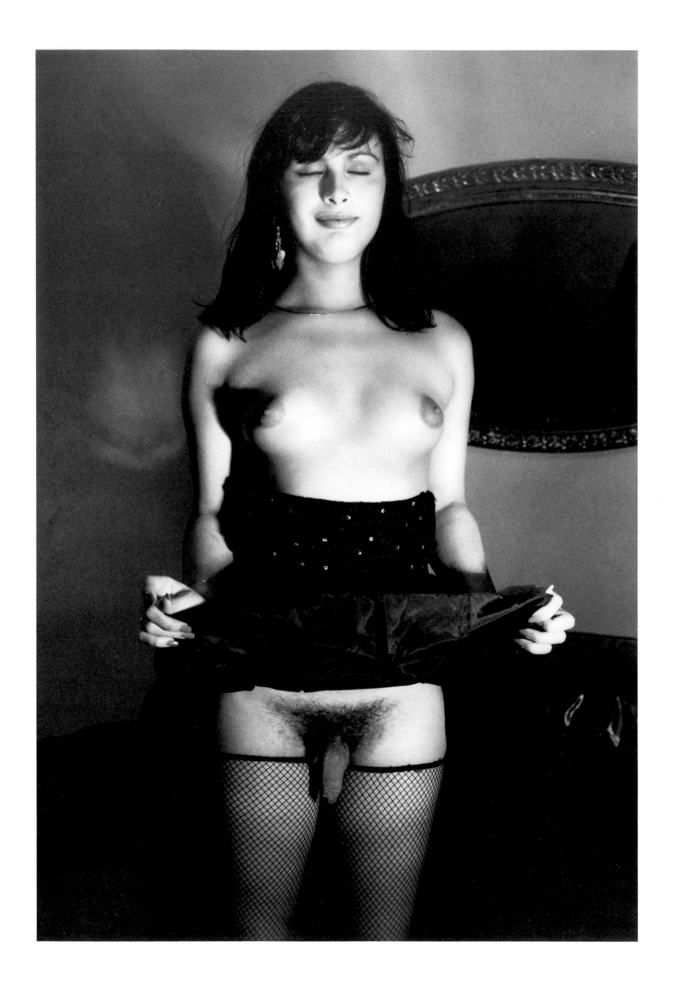

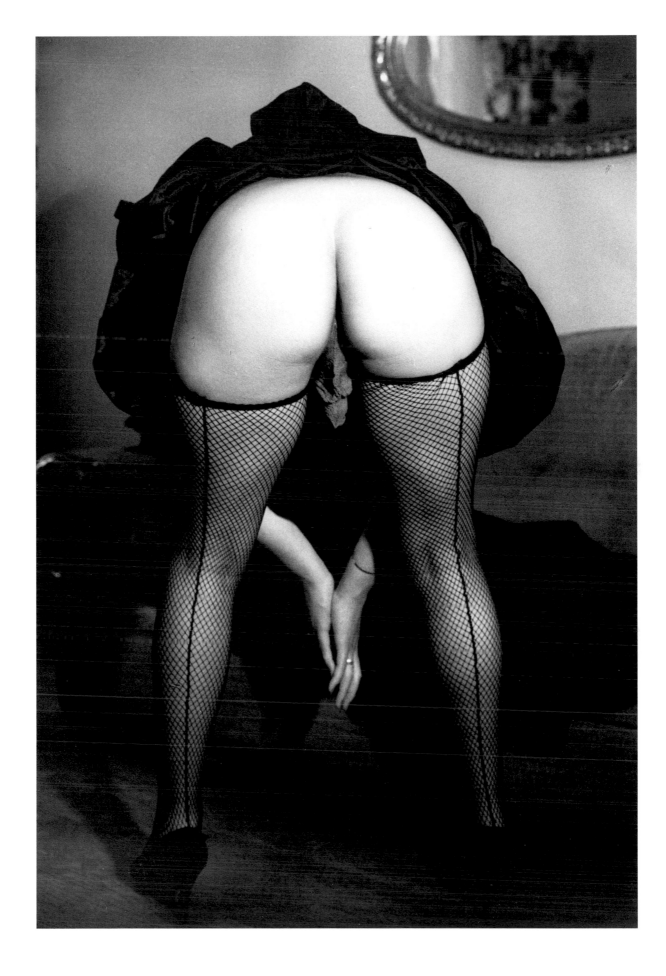

Sophie
1986

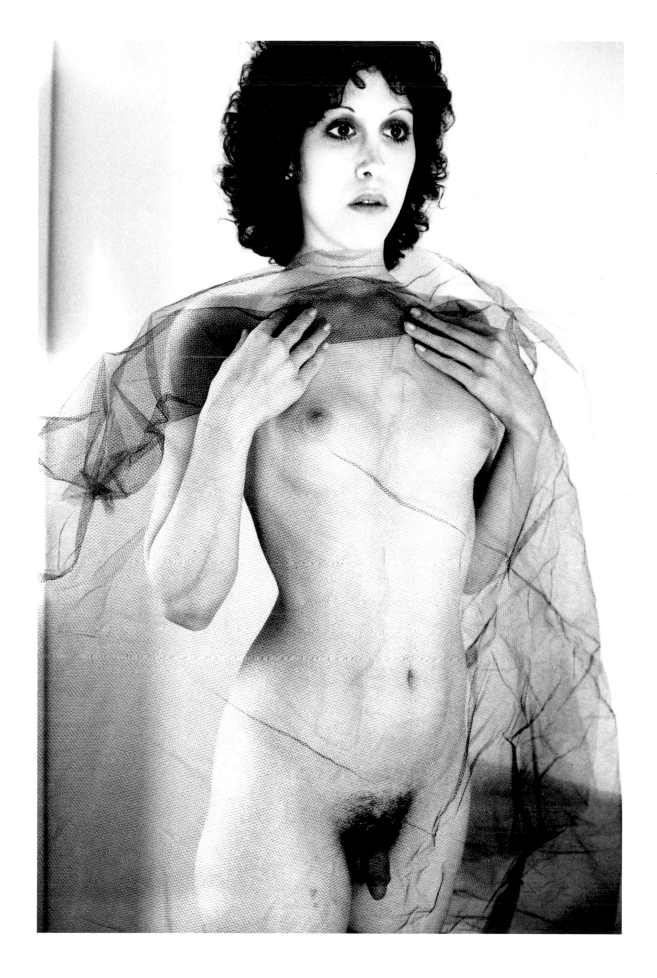

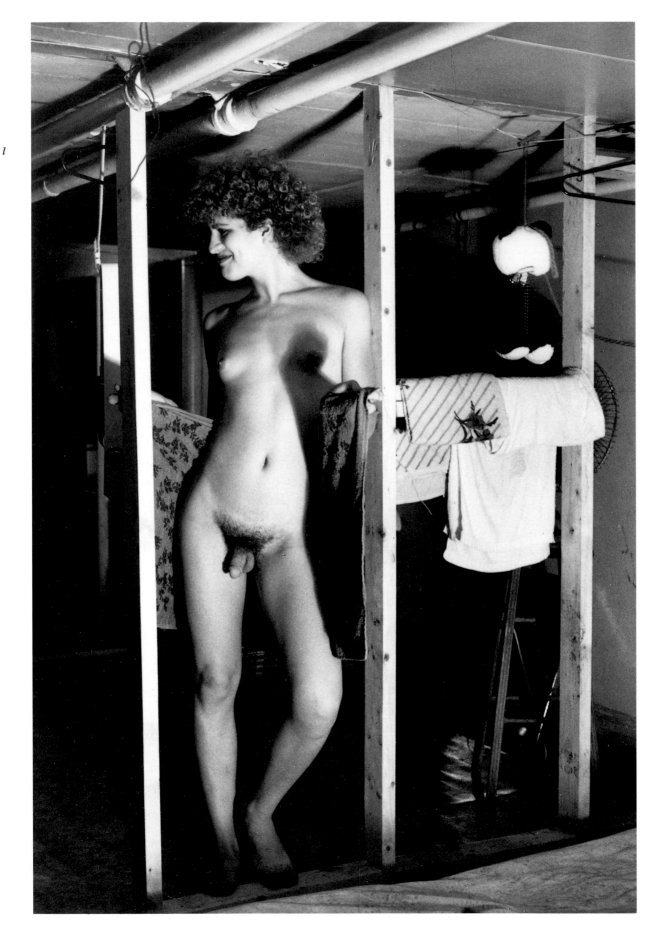

Abigail
1986

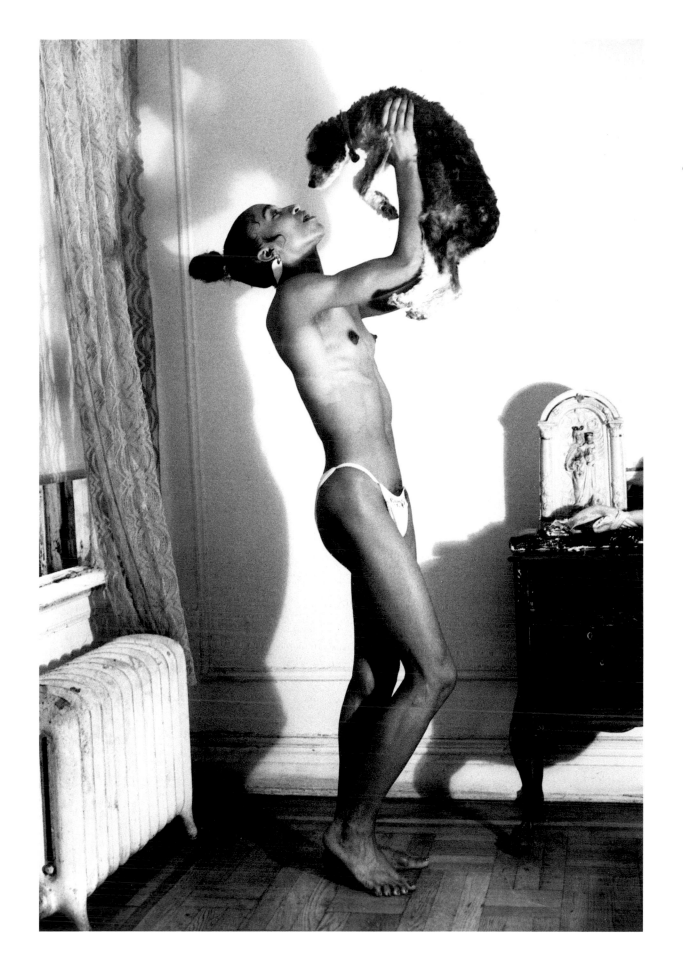

Chloé
1986

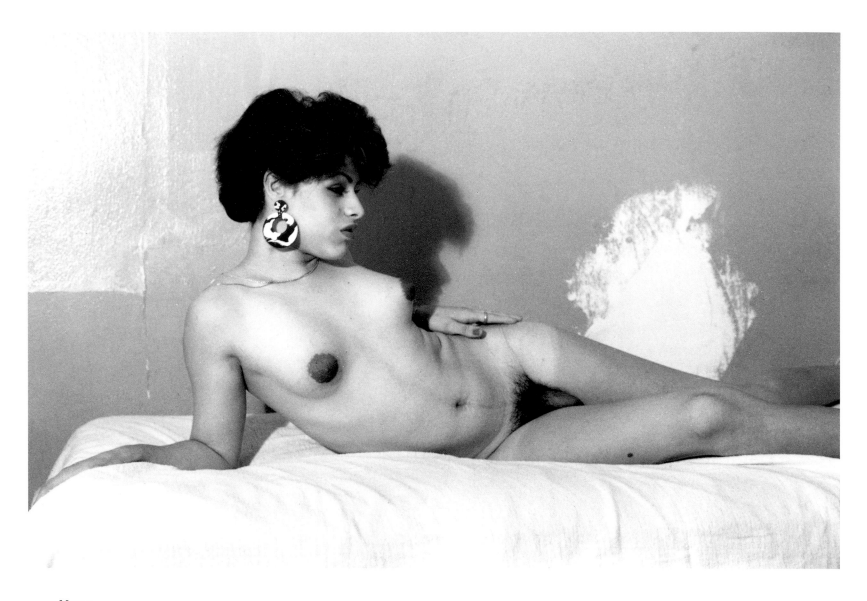

Myra

1986

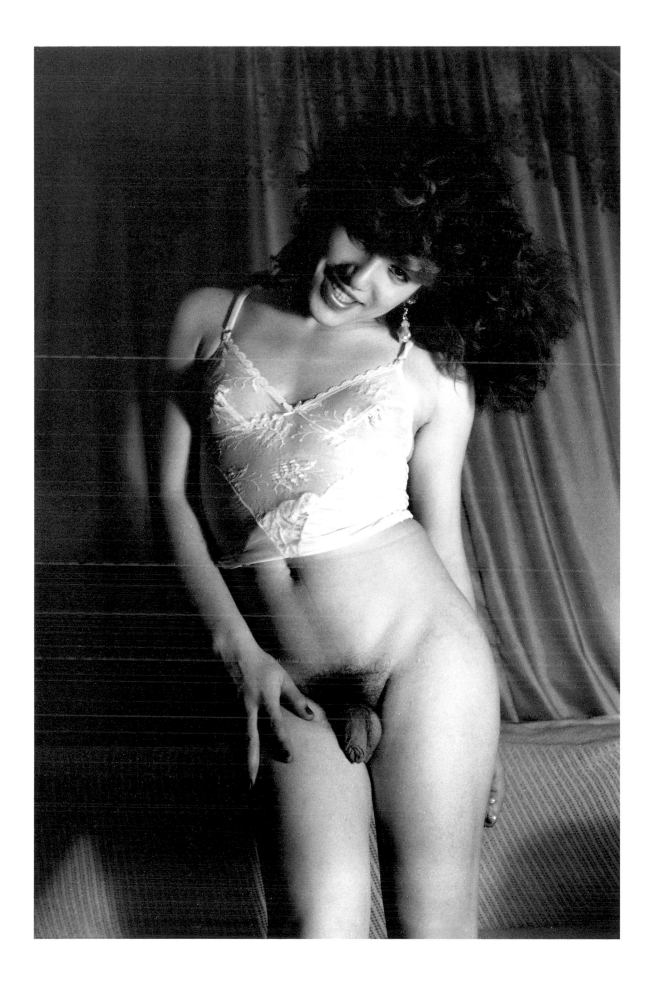

Sacha
1987

Jennie
1987

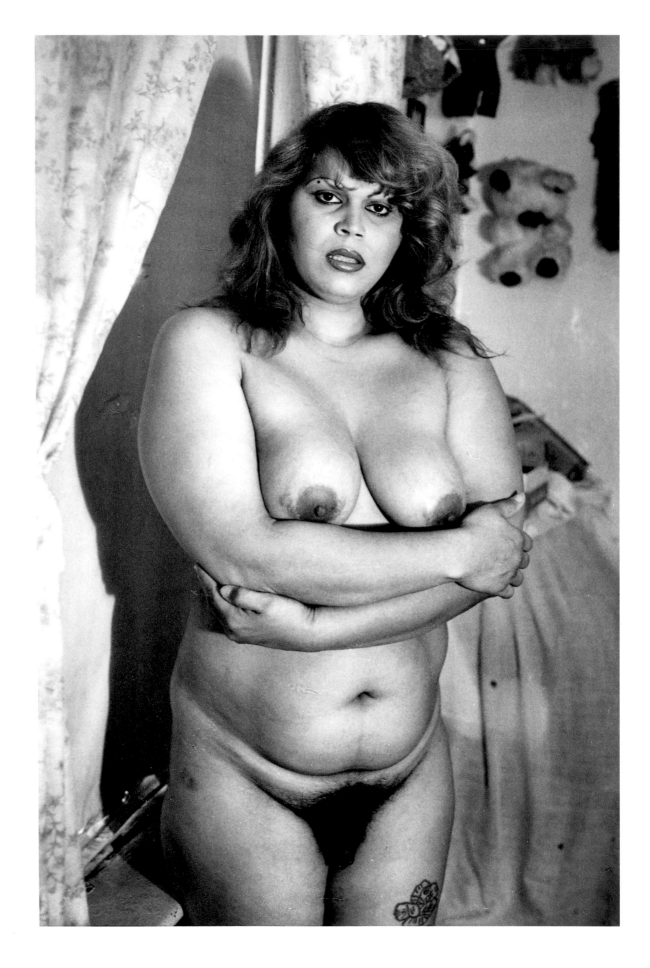

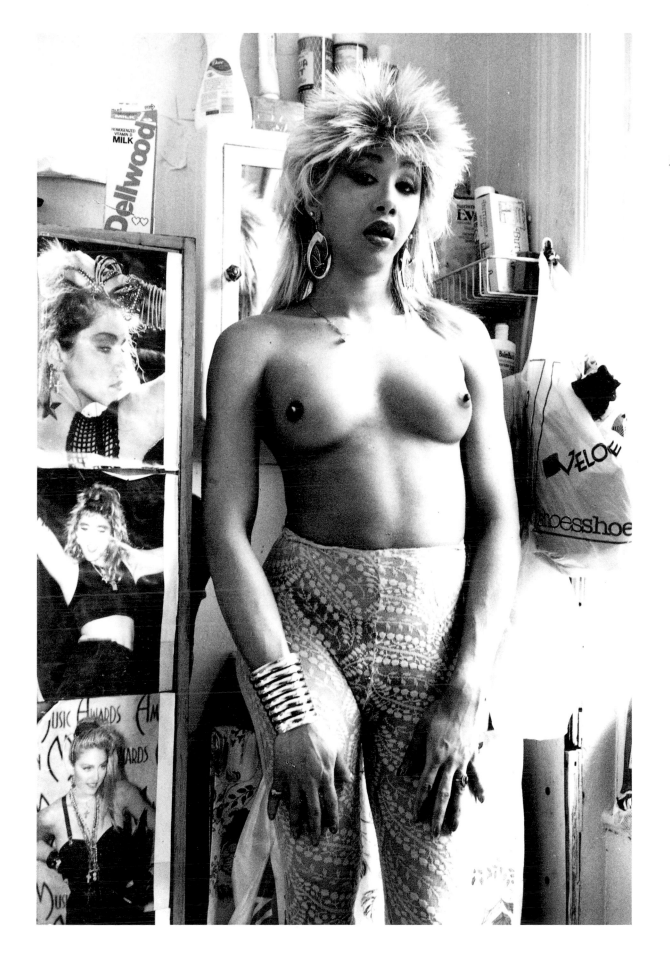

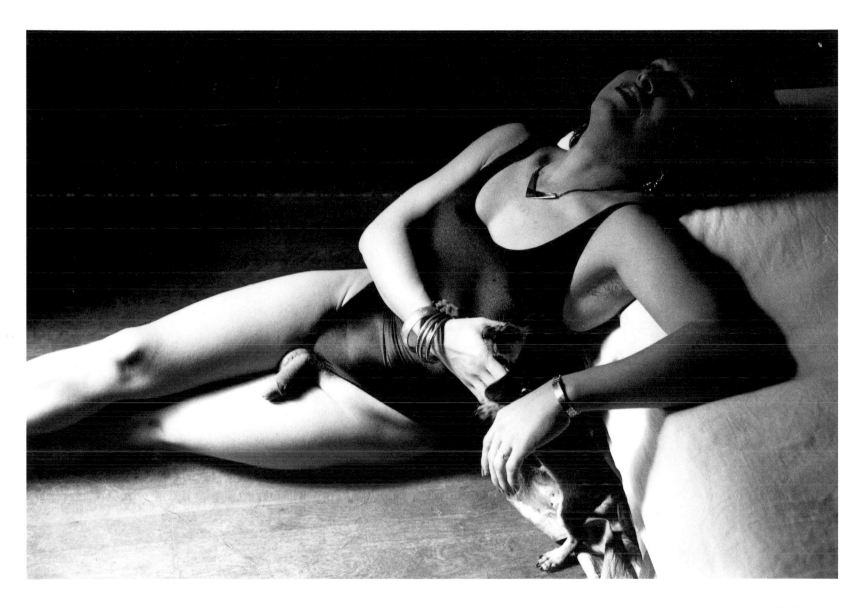

Ruby

1986

113

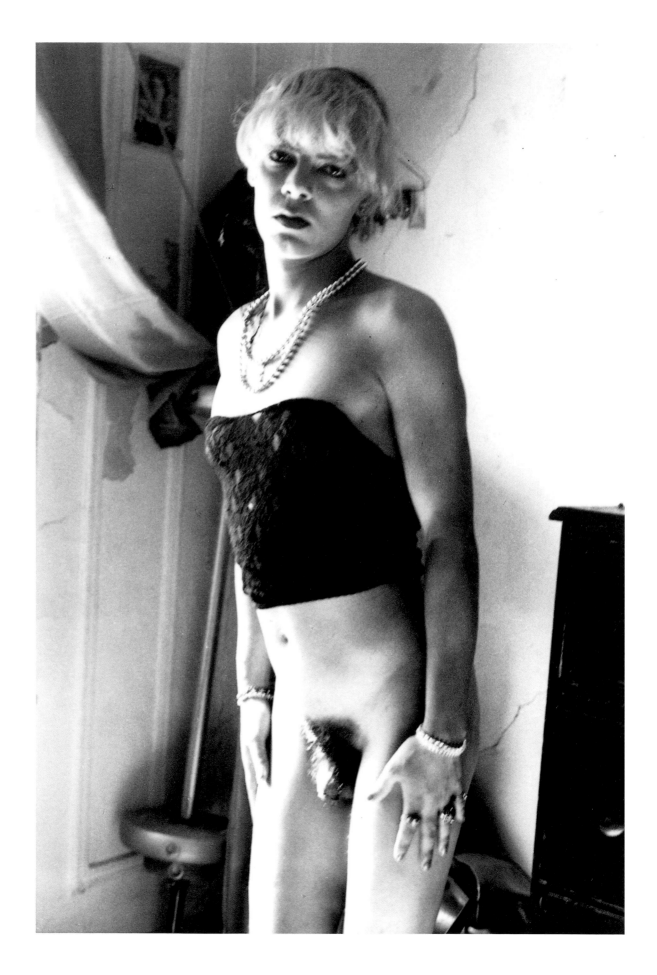

Gloria
1986

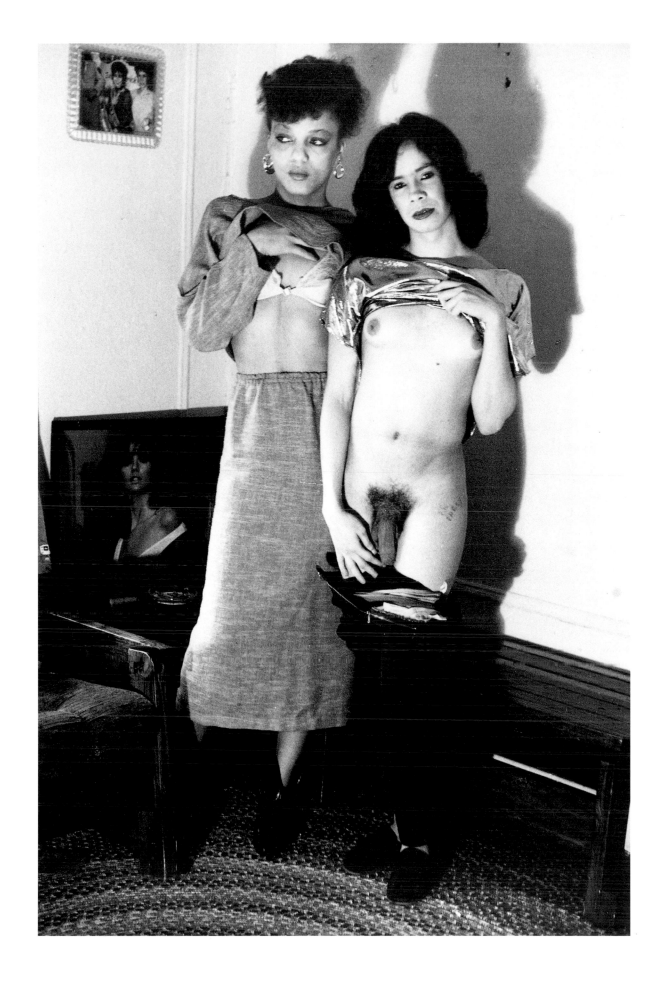

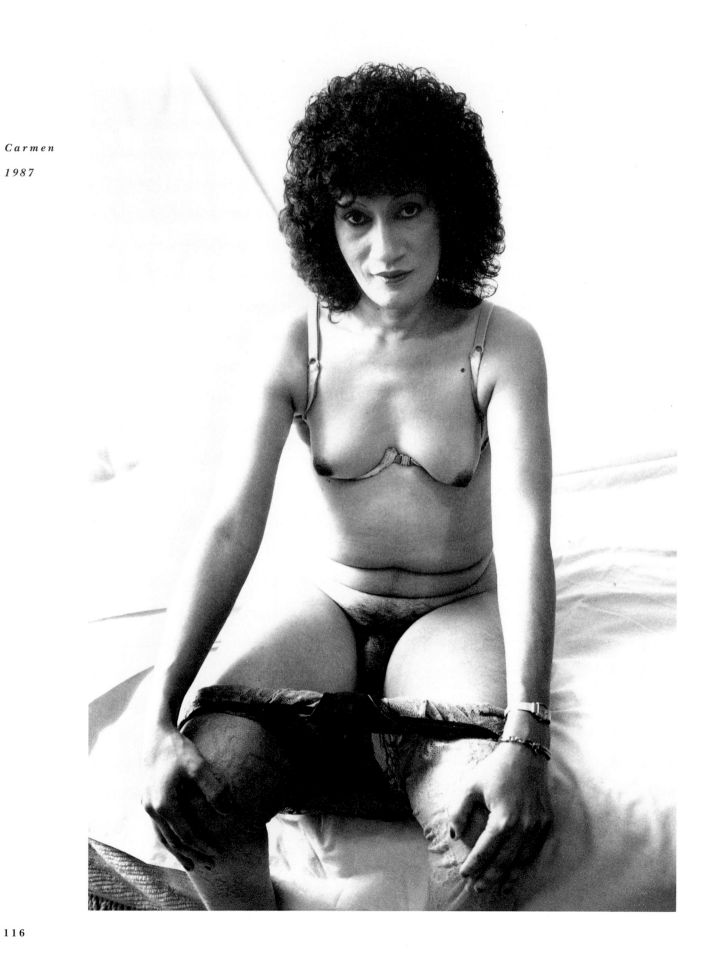

Carmen

1987

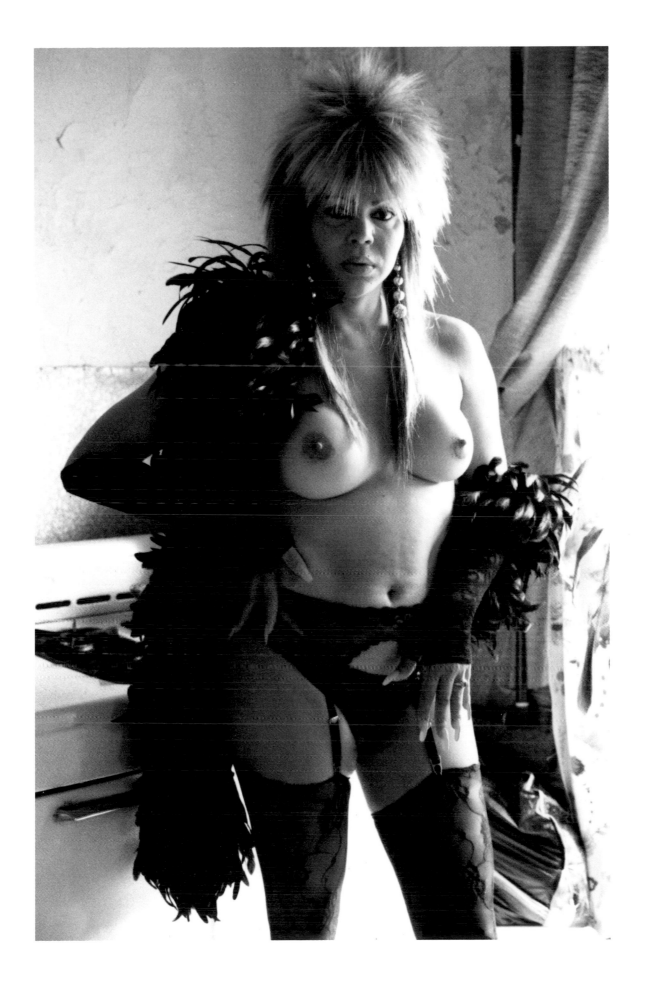

Judy
1987

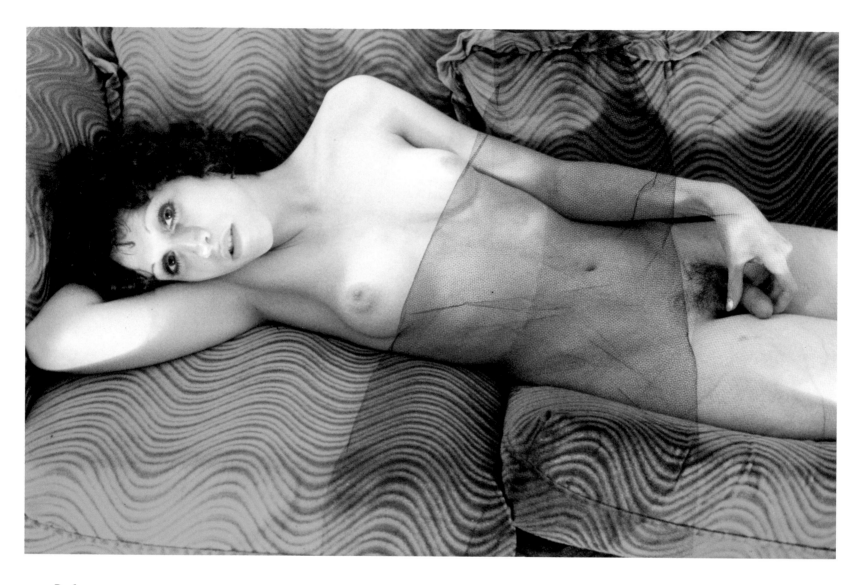

Dolores

1986

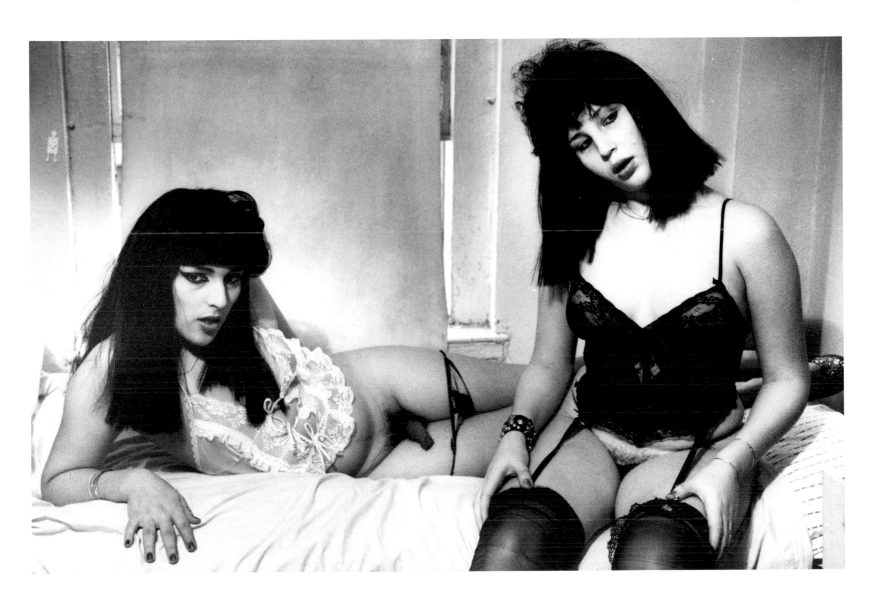

Jennifer & Tonya

1987

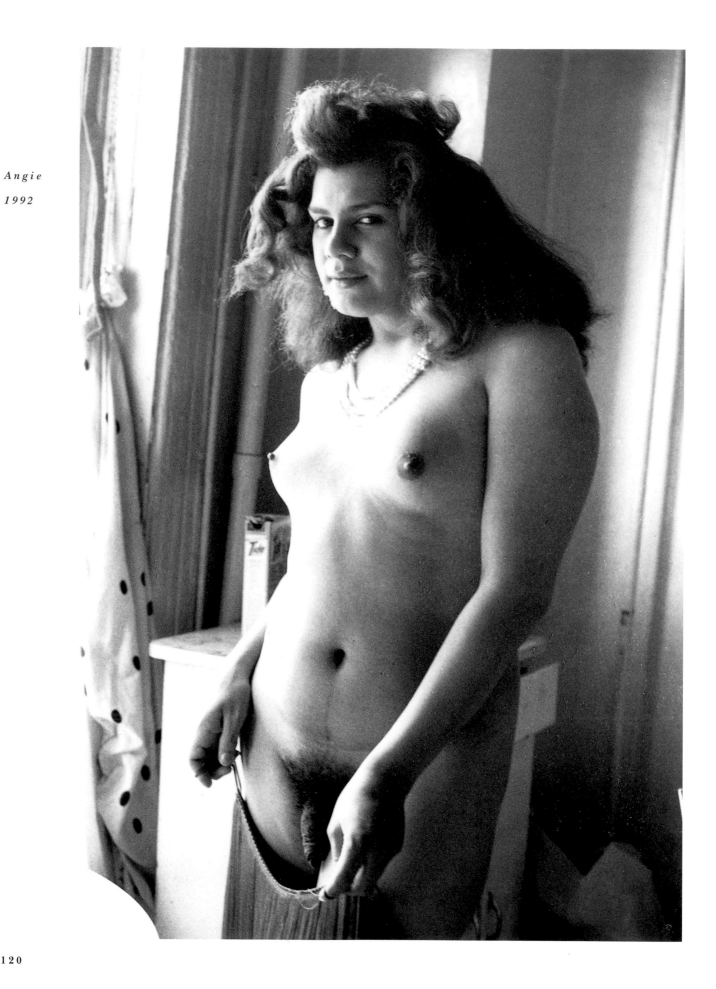

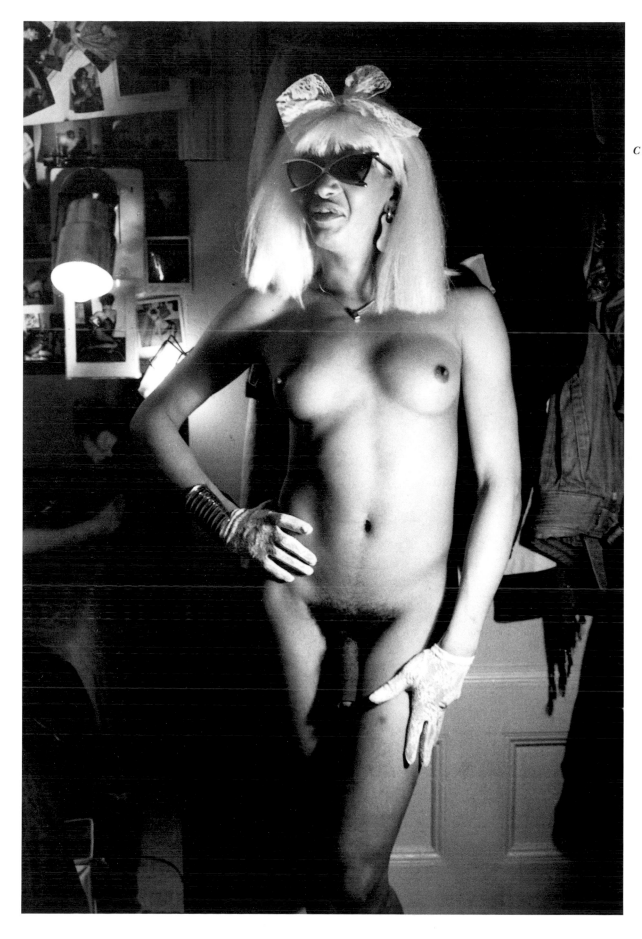

Cassandra

1987

Michelle
1987

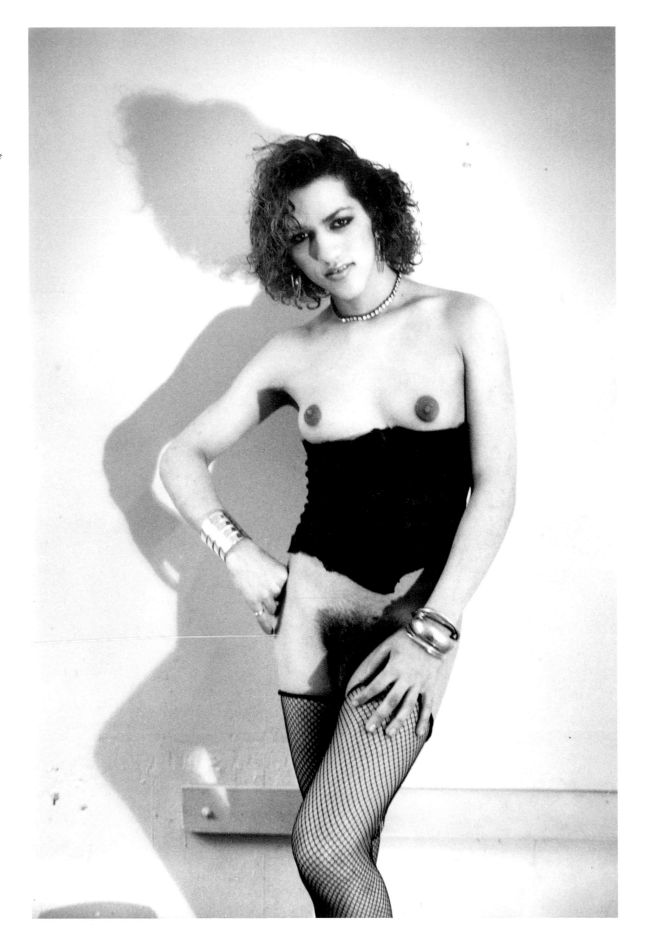

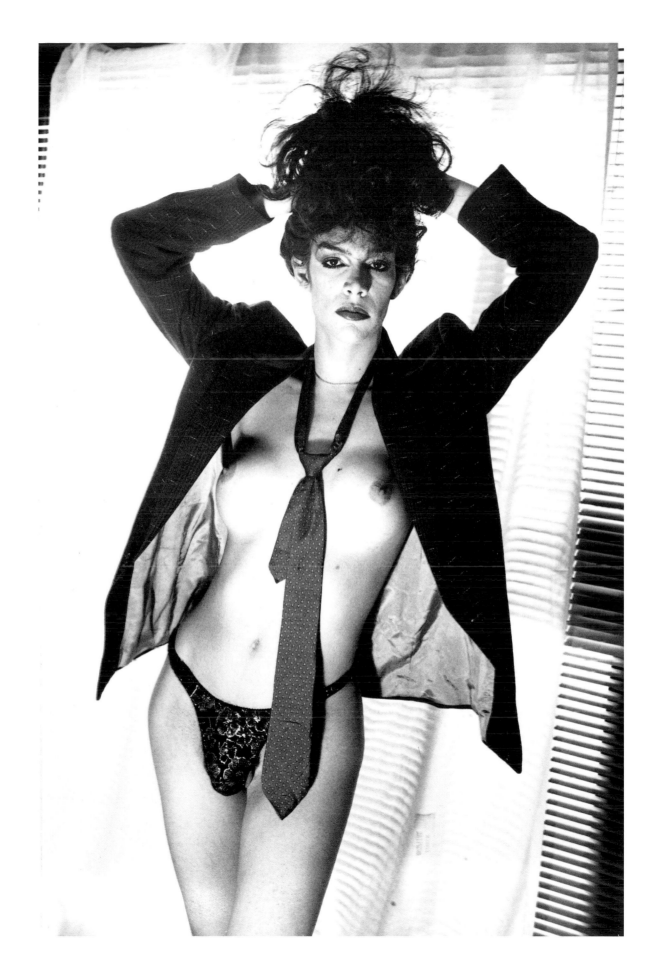

Angie
1992

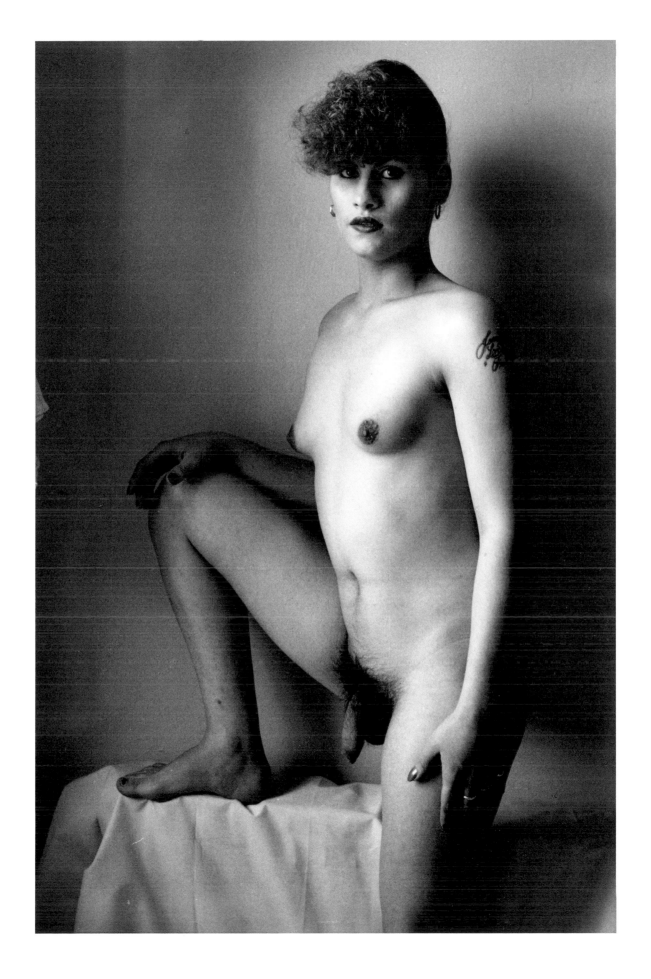

VIVIENNE MARICEVIC

All photographic series are photographed for at least two years or more and all subsequent series evolve from the previous one.

Vivienne Maricevic began photographing environmental male nudes in 1978 when she noticed that photographs of the male nude were rarely published or exhibited. Her newspaper ad "female photographer seeks men for nude photography" supplied her with many subjects. In 1979 she had her first one-woman exhibition, "Naked Men" in New York.

The "Male Burlesk" series started when Vivienne Maricevic was handed a flyer for a club featuring male dancers while she was walking down Broadway in New York City. She persuaded the manager and dancers to allow her to photograph them and continued documenting the dancers at "The Ramrod", "Big Top", "Eros" and many other clubs. The photographs were exhibited and published as a portfolio in "Camera Arts" magazine in 1981.

Being in the Times Square area and seeing marquees featuring "Live Sex Shows" brought her into the "Show World Center". Again, convincing management and performers to allow her to photograph, she went on to explore the other establishments featuring sex acts at "The Avon", "Les Girls", "Bryant Theatre" and "The Pussycat". A portfolio was published in "Photo" in 1983 and in "Pure" in 1995.

Vivienne Maricevic envisioned the "Porn Stars" series while photographing the sex acts, which also featured X-rated performers as the main attraction. Wanting to photograph these X-rated performers nonexplicitly, she approached them with her erotic black and white photos, which led to photos with accompanying interviews. This series was exhibited and published as a portfolio in "Photo" in 1985.

While in the dressing room of "Show World Center", Vivienne Maricevic met her first male-to-female transsexual in 1986 to photograph. "Show World" had hired the transsexual to recruit other transsexuals to work there. Noticing her attractiveness and the inability to know that she was once a man, Vivienne Maricevic wanted to meet others to photograph. Frequenting "Sally's Hideway", "Edelweiss", "Club Emotions" and culling names and phone numbers from "Screw's" newspaper, she met transsexuals, transvestites and drag queens to photograph in their home environments. Since the majority of transsexuals resemble regular women, she convinced them, whenever possible, to pose nude. The transsexual photographs enabled her to become a recipient of a New York Foundation for the Arts Fellowship in 1987. The transvestites and drag queens were photographed as triptychs.

First, their male persona, secondly, their metamorphosis persona and thirdly, their female persona. This series, entitled "La Cage aux Folles" was exhibited at the Neikrug Gallery in 1989.

Currently, Vivienne Maricevic is photographing female-to-male transsexuals, male impersonators, transgenderists and androgynous women as a series, entitled "Gender Disarray".

Vivienne Maricevic was born in Westchester County, New York, forty-plus years ago and worked as a picture researcher for "True" magazine, an exhibits editor for "Camera Arts" magazine and currently as the photo editor for "Crescent Publishing Group". She resides in New York City with her husband, Michael Reynolds.

SOLO EXHIBITIONS:

1979: "Naked Men", Kata Gallery, New York, NY; 1981: "Male Burlesk", Leslie-Lohman Gallery, New York, NY; 1985: "Porn Stars", Yuen Lui Gallery, Seattle, WA; 1989: "La Cage aux Folles", Neikrug Gallery, New York, NY

GROUP EXHIBITIONS:

1978: "Women See Men", ICP, New York, NY; 1981: "American Nudes", MIT, Cambridge, MA; 1982: "Perceptions", Parsons School, New York, NY; "Erotica", Cameravision, Los Angeles, CA; 1985: "Nudes", Jacques Baruch, Chicago, IL; 1988: "Other", Houston Center for Photography, Houston, TX; 1990: "Women Photographers", Nikon House, New York, NY; 1993: "Sexarts 3", Folsom Gallery, San Francisco, CA

PUBLICATIONS:

"Nudes" in: *Women See Men*, New York, NY: McGraw-Hill Book Co., 1977; "Nudes" in: *Male Nude in Photography*, Waitsfield, VT· Vermont Crossroads Press, 1979; "Nudes" in: *New American Nudes*, New York, NY: Morgan & Morgan, Dobbs Ferry, 1981; "Male Burlesk" (portfolio) in: *Camera Arts Magazine*, September / October, 1981; "Nudes" in: *Erotic Photography*, Trenton, NJ: Demarais Studio Press, 1981; "Spain" (portfolio) in: *Latin NY Magazine*, April, 1983; "Live Sex Shows" (portfolio) in: *Photo* (Paris), August, 1983; Vivienne Maricevic, interviews with Porn Stars in: *Penthouse Letters Magazine*, October, 1983; "Nudes" (portfolio) in: *Photography Annual*, New York, NY, 1984; Cover photo / "Male Burlesk" (portfolio) in: *Christopher Street Magazine*, November, 1985; "Porn Stars" (portfolio) in: *Photo* (Paris), December, 1985; "Nudes" (portfolio) in: *fotoMAGAZIN*, February, 1986; "Live Sex Shows" (portfolio) in: *Liebe zu kaufen*, Schaffhausen: Edition Stemmle / Verlag "Photographie" AG, 1987; "Live Sex Shows" (portfolio) in: *Foto-Scene*, November / December, 1987; "Nudes" in: *Erotic by Nature*, No. San Juan, CA: Shakti Press / Red Alder Books, 1988; Vivienne Maricevic, interviews with Porn Stars / cover photo in: *The Portable Lower Eastside*, no. 8, 1991; "Life Sex Shows" (portfolio) in: *Pure Magazine*, February, 1995

AWARDS:

NY Foundation for the Arts Fellowship, New York, NY, 1987; Artist Grant, Artists Space, New York, NY, 1989

COLLECTIONS:

International Center of Photography, New York, NY; Private Collections

"As far back as I can remember, I have always been attracted to people, places and things that were different. The road less travelled has always been my choice to explore. Therefore it was natural for me to be interested in photographing subject matter that offers many challenges, obstacles and difficulties dealing with the pathology of our times with references to sociology and psychology.

Transsexuals are unique in that they are compelled to come to terms with the male and female aspects of their personalities and bodies. Many transsexuals look like regular women in full-dress all the time, so it was important for me to convince them to be photographed nude. The majority feel that there are many men and women, but only a small group who are 'special', meaning they have breasts and a penis.

The triptychs of the transvestites and drag queens reveal the temporary metamorphosis of men who choose to transform their image to relieve male pressures or for the fun of it.

It is all about sexual stereotypes, the making, breaking and reshaping of those roles. This series concentrates on men who have explored these realms. They all can be viewed as accepting the yin-yang manifestations within us all and remembering that we are all different, unique and beautiful."

Vivienne Maricevic

I would like to thank the following people for their past and present support:

Dr. Thomas N. Stemmle for publishing my first book

Miles Barth, Arthur Goldsmith and Jim Hughes for their encouragement

Vicki Goldberg for the introduction

Annie Sprinkle, Johnny Armstrong and Dr. Catherine Racklin for inclusion to their socials

From the bottom of my heart, a very special thank-you to all who appear in this publication,

for without them, this book would still be a dream and not the reality it has become.

Most of all, I thank my husband, Michael Reynolds

for always understanding and believing with me.

Vivienne Maricevic

Photo reproduction copyright © by Vivienne Maricevic

Text copyright © by the authors

Editorial direction by Mirjam Ghisleni-Stemmle

Art direction by Grafikdesign Peter Wassermann, Andrea Hostettler, Flurlingen, Switzerland

Printed and bound by EBS Editoriale Bortolazzi-Stei s.r.l., San Giovanni Lupatoto (Verona), Italy

ISBN 3-905514-86-9